I'll Have a Cappuccino Please

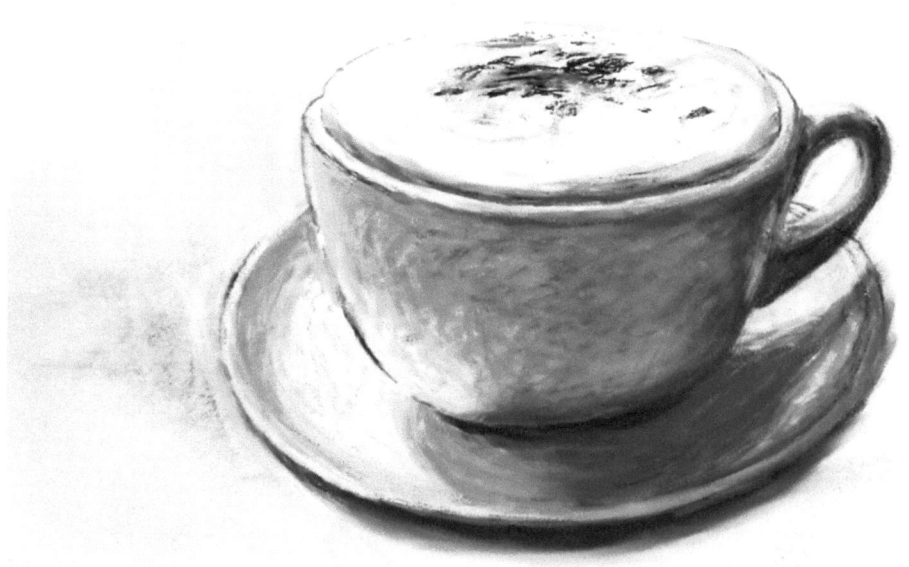

The Cornelia Street Café Drawings
Created at the Cornelia Street Café
Greenwich Village, NYC
Circa 1980

Pat Preble

www.patpreble.com

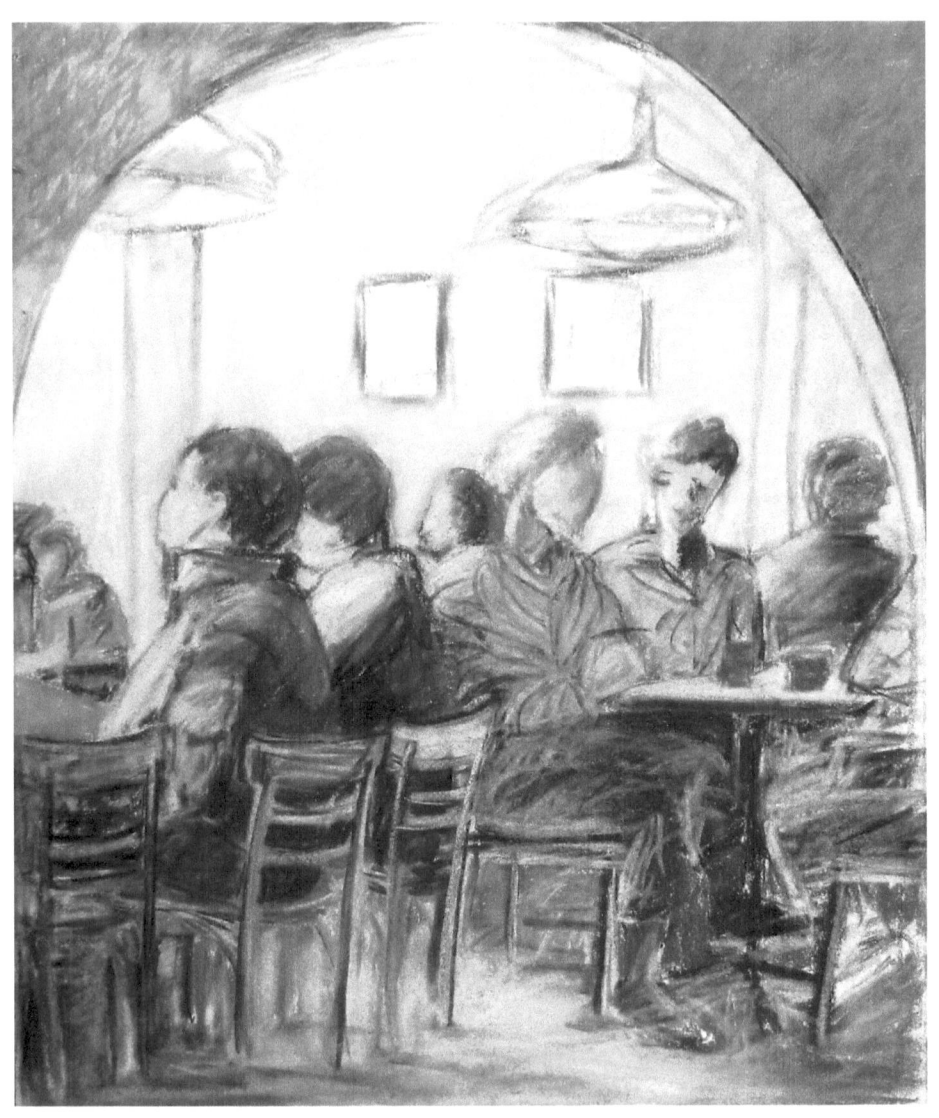

Copyright © 2018 Pat Preble
All rights reserved
ISBN-13: 978-1534969971
ISBN-10: 153496997
Published through Amazon

INTRODUCTION

The first edition of this book was created in 1985. It was quite small; four copies made on a Xerox machine. Technology has changed dramatically. A digital camera and Photoshop compared to an old Xerox machine create exceptional reproductions of the drawings.

The second edition was created as a Kindle eBook. That was a bit of a learning curve compared to using a Xerox machine. Now I am ready to face the formatting extravaganza that Createspace presents as an anti-Alzheimer's exercise in new learning and am making a 21st Century paper edition.

Part I of this edition is a true rendering of the original Xerox book "I'll Have A Cappuccino Please". In the Kindle Edition, I expanded the book to include a second section, "I'll Have Another Cup", which discussed the development of the drawings and showed how a drawing developed from a sketch into final form. In this edition I will expand a bit more on the drawing process.

The original book was a philosophical prose poem set to the drawings. The original stands on its own, but I find that people are as interested in the artistic process as they are in the results and am including an explanation of how the drawings were made.

ART MAKING

When I was two years old my grandfather used to draw pictures for me. My memory is that he had a stick and when he would touch it to paper it seemed to my child's eyes that "stuff" came out of it onto the paper. It looked like magic. The stuff would be a

squiggling mass of lines and then suddenly, as I watched transfixed, the amorphous mass turned into pictures of ducks and squirrels. I thought to myself, 'I want to do that too!'

I colored and drew things all throughout my childhood. My first kindergarten paintings were of my grandparents' farm and animals.

In grade school I would spend hours looking at trees, drawing their many branches and filling them with individually drawn leaves. To discourage this behavior, my third grade teacher moved me from a window seat to the front row by the door where she could keep an eye on me and make sure I was paying attention to the black board.

During high school I went out into the countryside with friends to draw. That was the beginning of my impressionism.

Over the years, by myself or with other artists as companions, I have traveled from the oceans to the mountains and back again drawing the landscape. It's very meditative, out in the wild somewhere, focusing on the highlights and shadows of the landscape and rendering my impressions of light and color. When I moved into New York City I realized that my usual concept of landscape would have to be changed.

I spent quite a bit of time walking through various neighborhoods from 57th Street all the way down to Wall Street getting familiar with the city and looking, just looking at the buildings and the people. I really was not very interested in drawing buildings. Then I found the Cornelia Street Café.

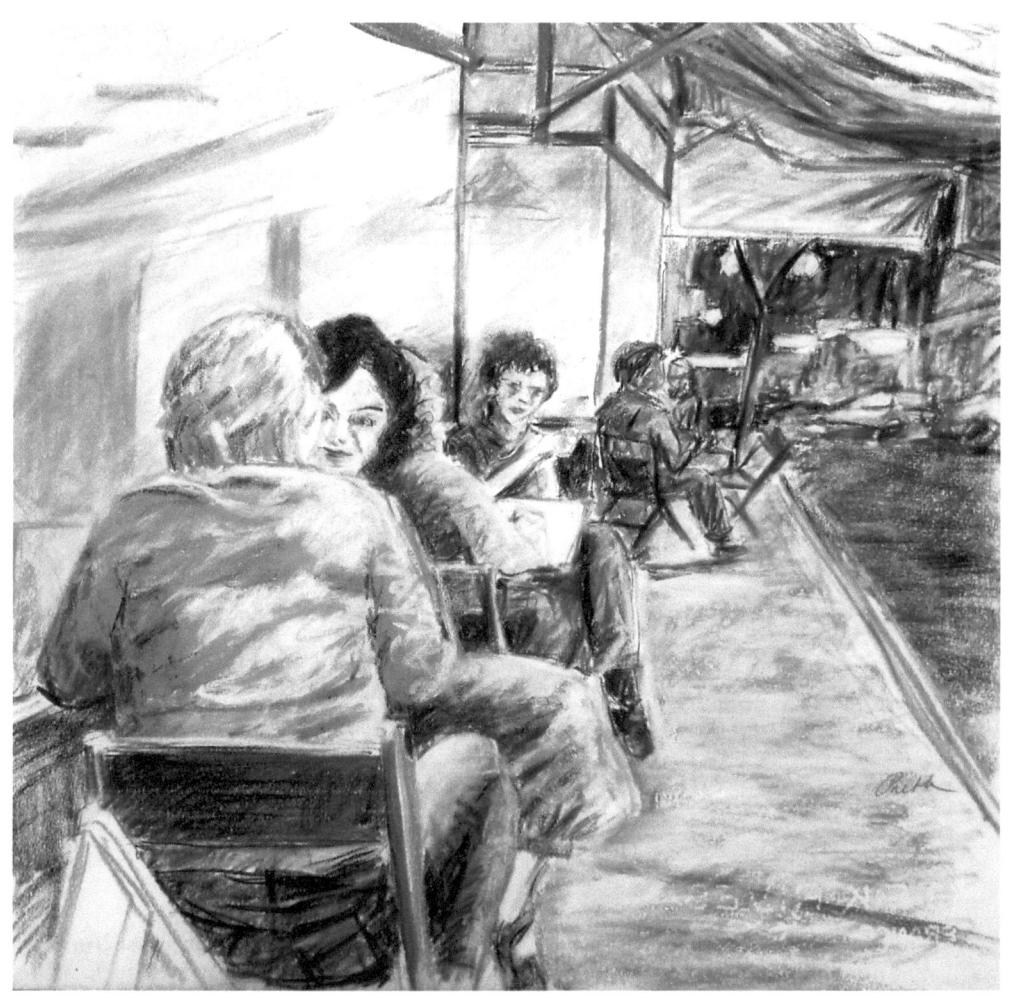

I had been looking for a subject for drawings and thinking about finding a figure drawing studio. But in the café I was thrilled by the subtleties of highlight and shadow I found there. Instead of going to a drawing studio I started to frequent the café with the express purpose of rendering those wonderful tones. I took no photographs, preferring to render the drawings in real time while sitting at a table or at the bar in the café.

Something happens in the moment that is particular to that moment of time which gets captured by the drawing. When I am in the studio I turn off the telephone and listen to very particular music which creates an ambiance that leads me into more meditative states. These states of reverie are imbued into the pictures I make. For the café, then, the reality of the moment was captured and I like that best.

There is a feeling tone in all of the drawings which comes from that immersion in the moment and while looking at them, you can experience a sense and feeling of a particular time period as if you were sitting there in the café with me.

(Following is the original book [complete with Courier Type Face])

I'll Have a Cappuccino Please

By

Pat Preble

Can writing wait?

Can a painting wait to be made?

Will it ever be made if the moment
of making passes to another day?

Would it be the same?

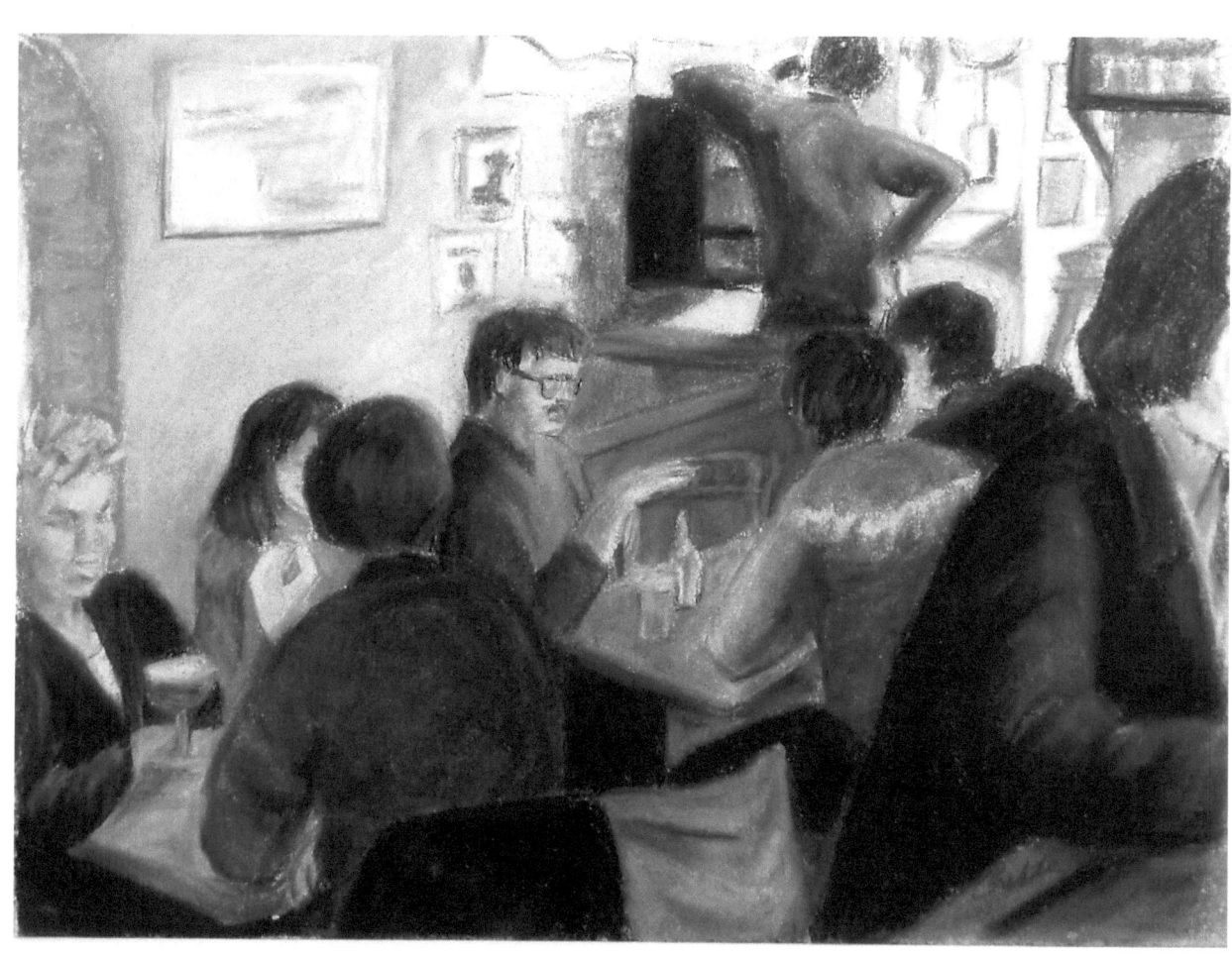

If it is made, it is what it is.
If it is not made, but only thought
of, who knows? Who knows?

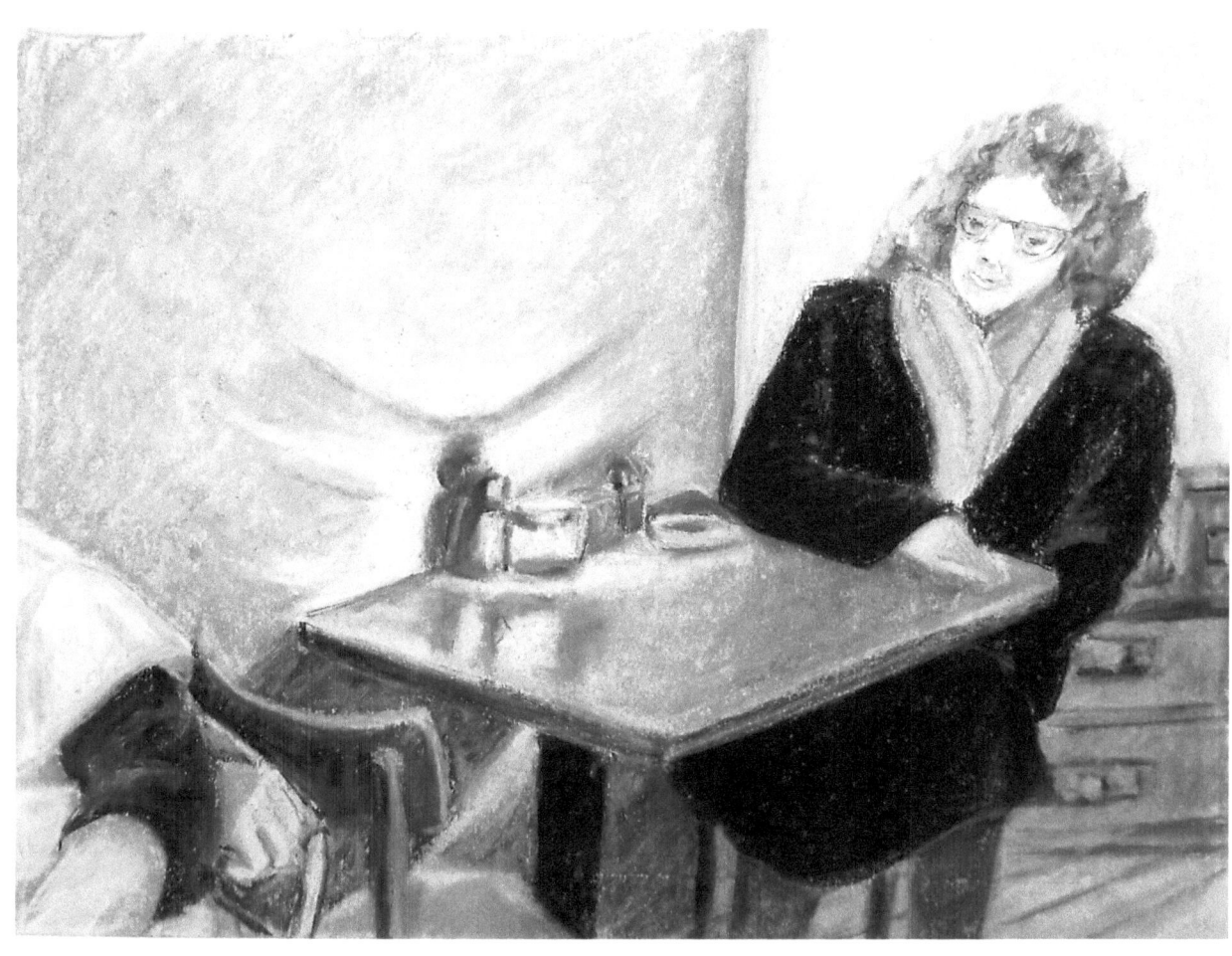

There are many pictures I have thought of to make, and have now forgotten what they would have been. Will they be made? Maybe. There are sketches for some of them I have made, intending to get back to them. Will I? Will they be the same pictures as they would have been had I made them when I thought of them? I don't think so. My technique of mark making keeps changing. . . . but, maybe the feeling will still be there. There's no way of knowing. Once it is made, it is what it is. If it is not made, then, well, it isn't there to tell if there is a difference. Maybe I could try making it twice at different times.

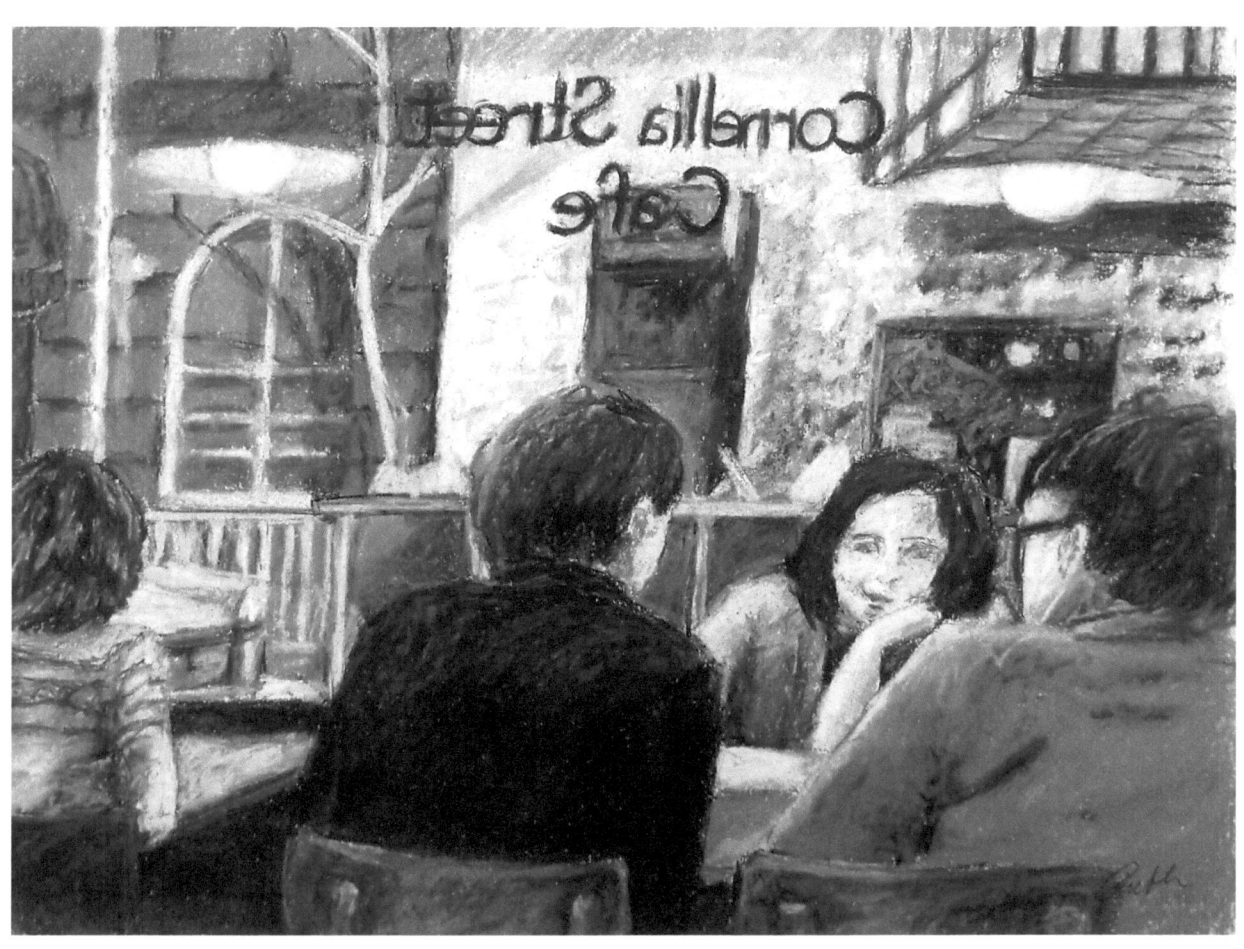

Wrapped within a time period, events flow through my life. Or, I flow through the events. In other time periods it feels to me that events flowed which, now that they have passed feel to have been something different from what I experience right now. This time is different. I am different. The past is a solid reality of its own and I can not touch it again except with my memory and, unfortunately, that keeps changing.

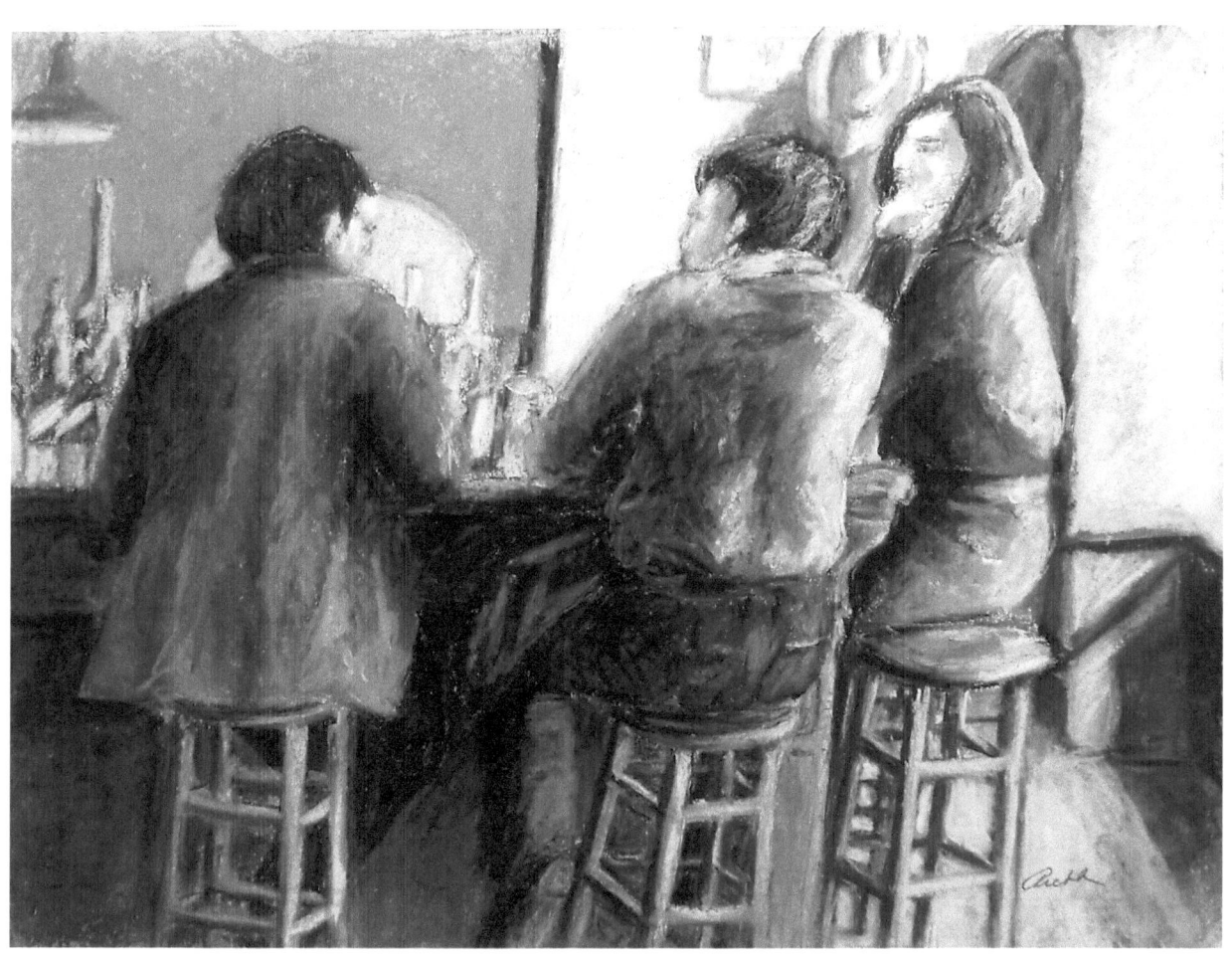

A time period is like that. Wrapped within a period of time events flow through our lives, or, my life flowed through many events that now in passing can be felt to have been something different than I experience right now. This time is different. I am different. The past is a solid reality of its own and I can no more go back to it than I can avoid being drawn inexorably toward some future time when even this moment now will be lost to me as well. I will not be able to touch this moment again.

Change.

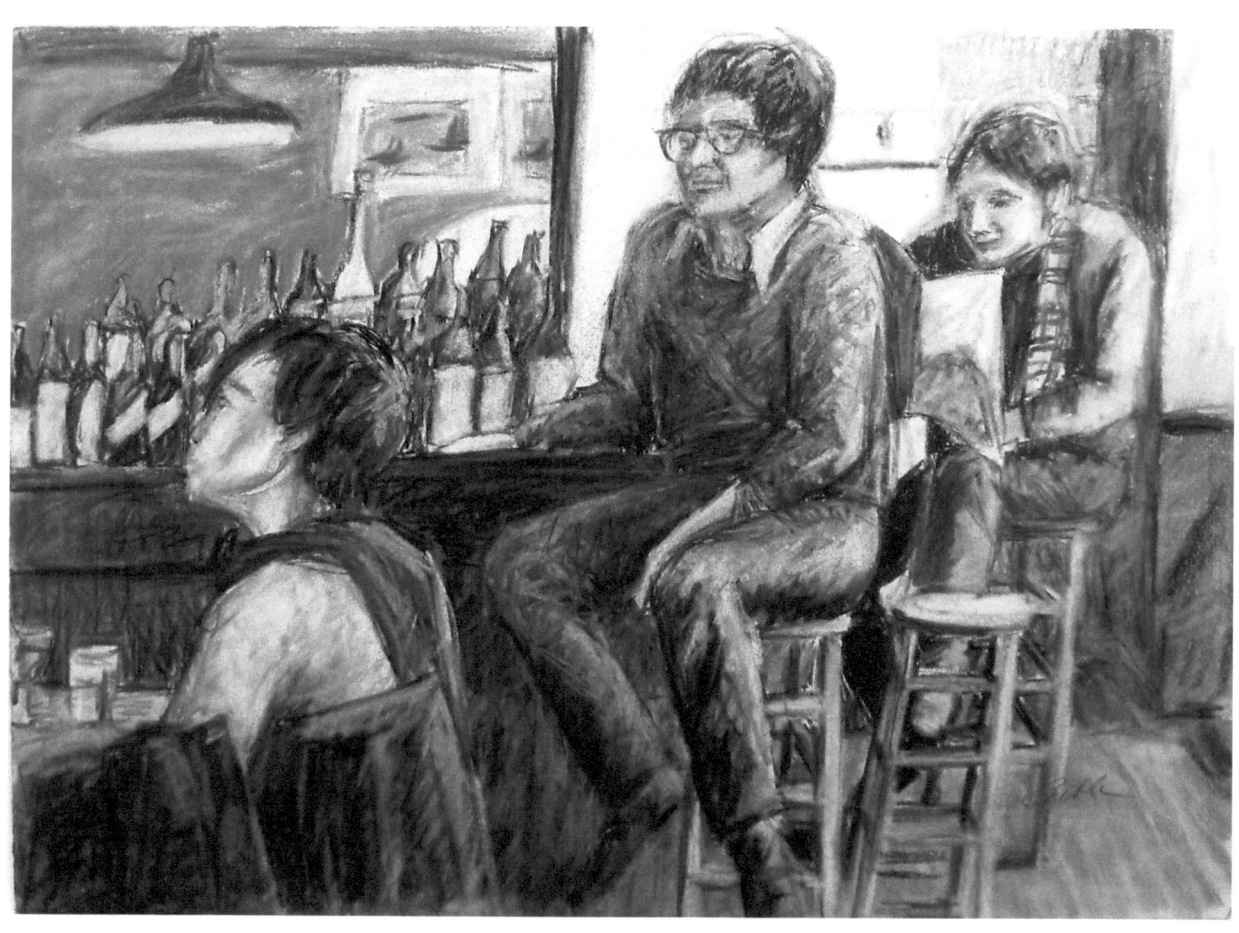

"All things change."

And to appreciate what was from this moment now is to appreciate this moment now for what it is, as it is, in itself. Present.

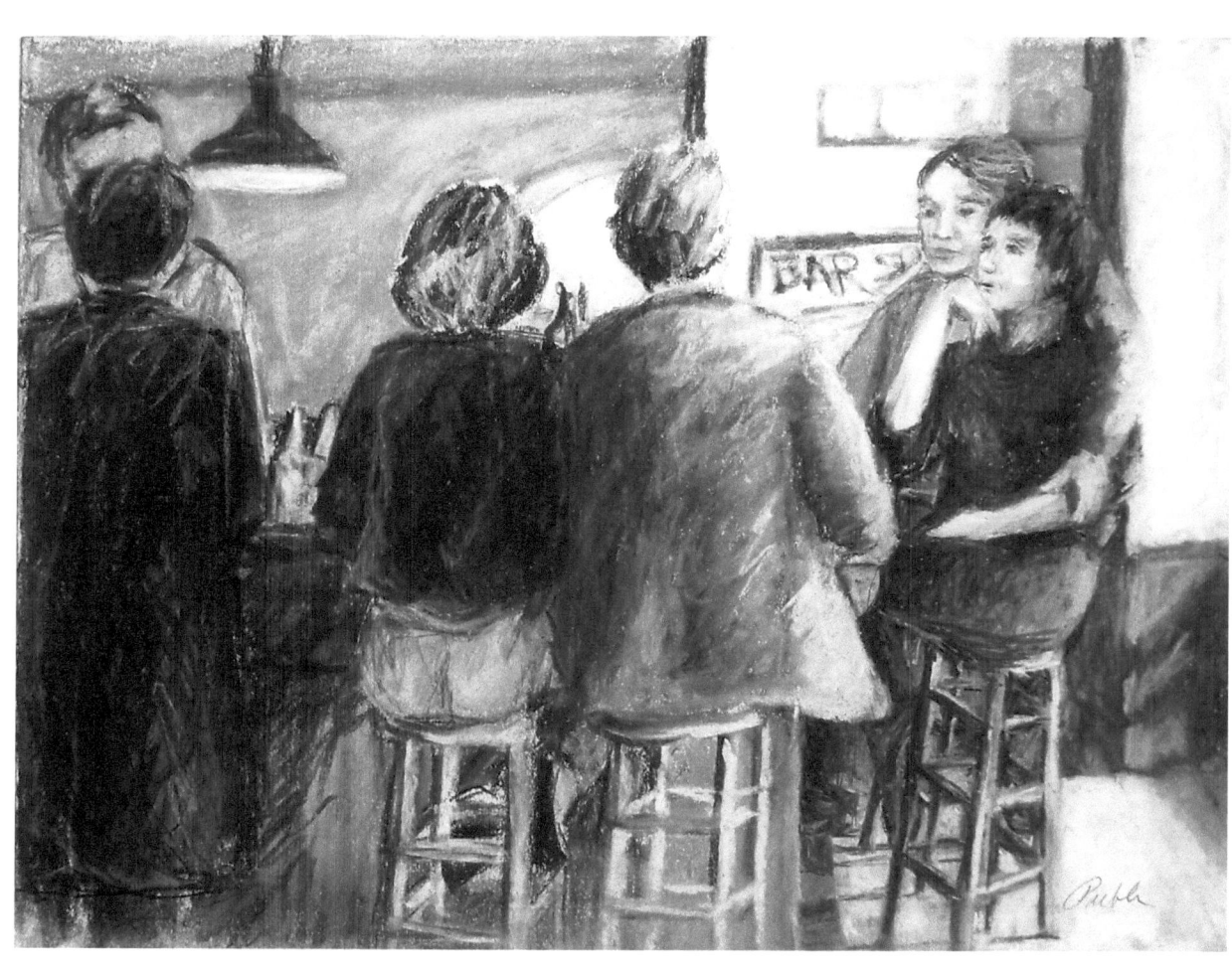

Growing older. Yes, growing older. All my life I've watched myself growing. Wishing to be grown when I was a child. In no way would I ever, at this moment, wish to be a child again, save, perhaps to keep alive that wonderment in the moment of now, when all the world was an eternity of time and there were things that were eternal, like trees that never seemed to change or die. But then, Dutch Elm disease came to my small town, and, in complete amazement, I saw trees die. I thought they could never die. But they did. I felt the first tear in my child's assessment of the world.

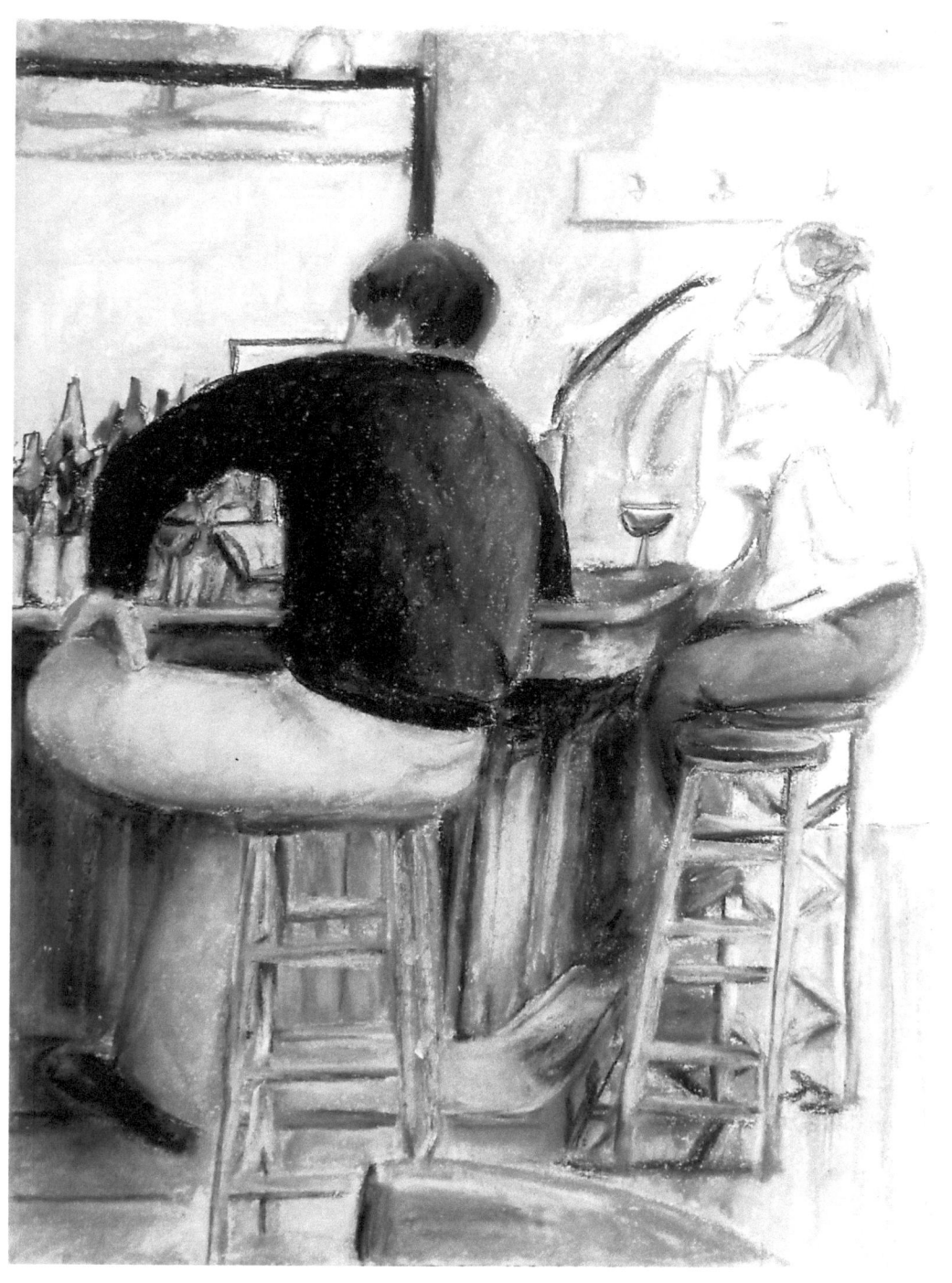

Watching myself grow year by year. Feeling the quickening of time as the relative length of one year compared to my increasing years diminished. Wondering about what is youth and what is age. Having lived long enough now that carnival rides give me motion sickness. I have to stay off of them. And, going to rock-n-roll clubs, the closeness of the air and the uncomfortable rhythm of music meant to jar the senses actually cause me to feel sick to my stomach. I am forced to leave. It's a kind of motion sickness there too, but, from too much uncoordinated sound.

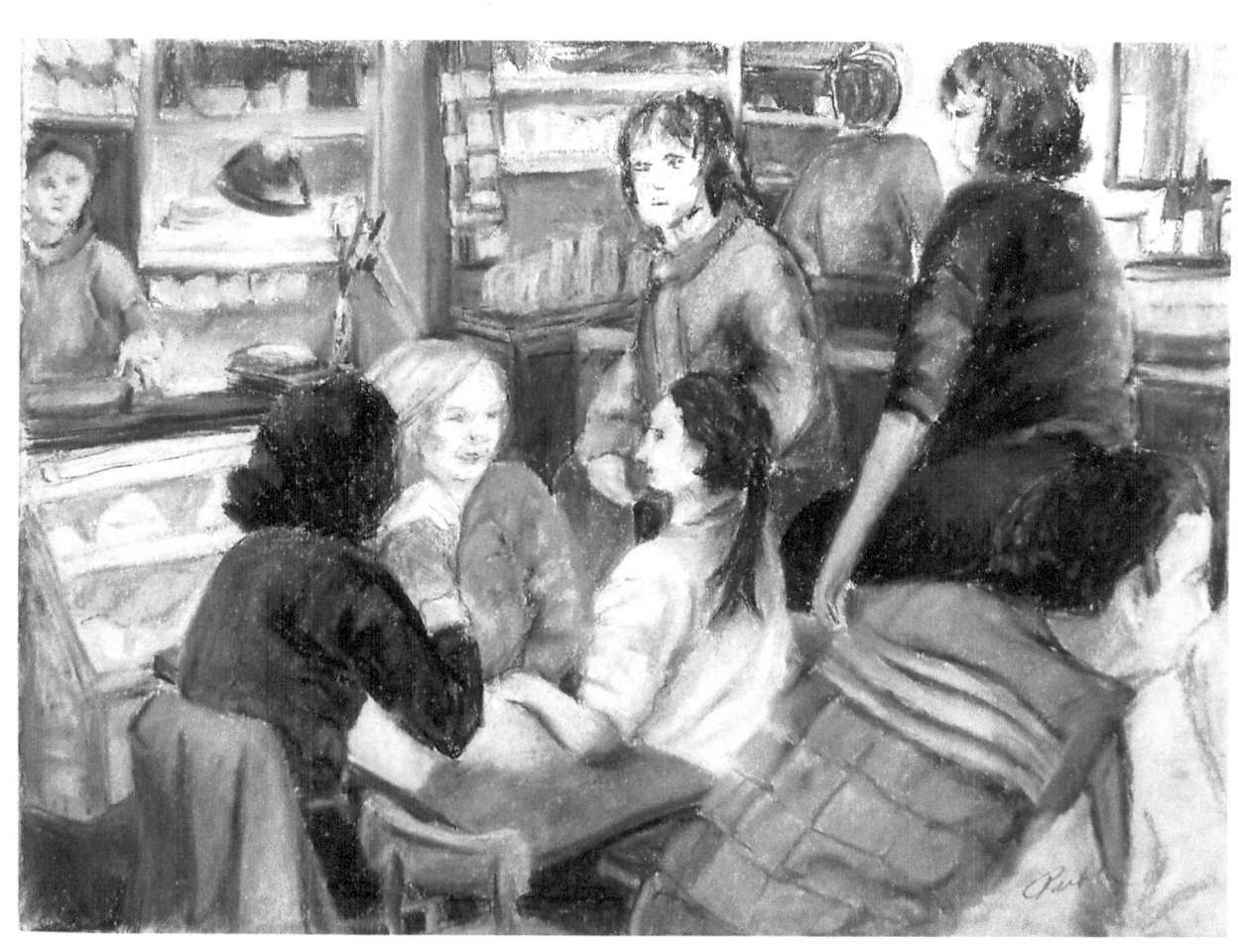

Having seen 'old' people on the street looking around themselves as if stunned. What did they see? Their eyes had an expression as though they had just awakened to an alien world and did not understand. I'm beginning to feel what they must have felt.

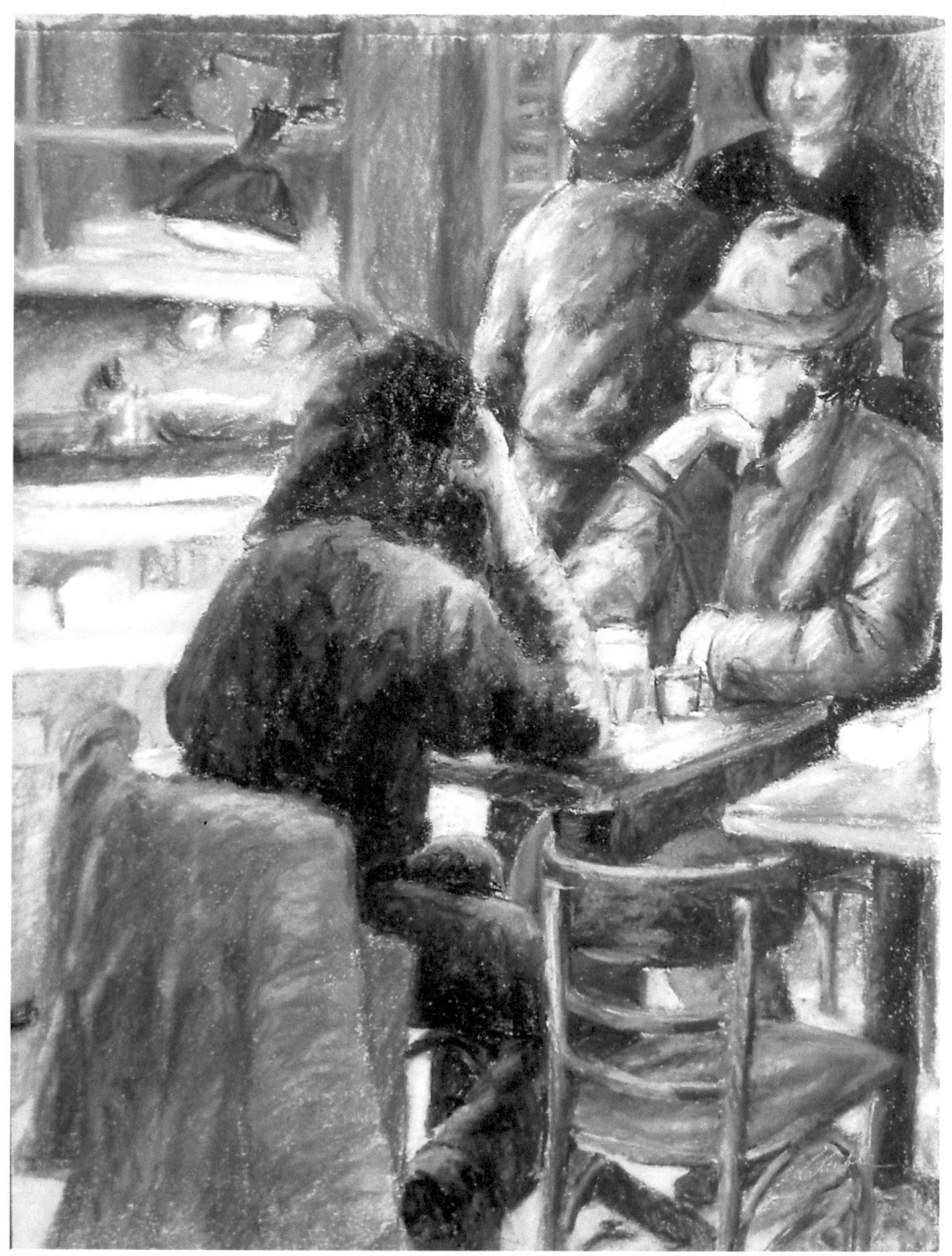

An interesting note. Confucius said that you could tell a decaying civilization by the amount of disharmony found in its music. Compare a song from 1945 on the hit parade with a pop song from one of the heavy metal rock stations, or, better yet, a punk-rock-rap-jazz-fusion 'song'. What do you hear today? Cacophony and dissonance. With each succeeding generation that I've experienced, it's been growing. Looking back to and comparing with the turn of the last century, it's possible to see that there is an incredible discord in the air now. What do you think that means?

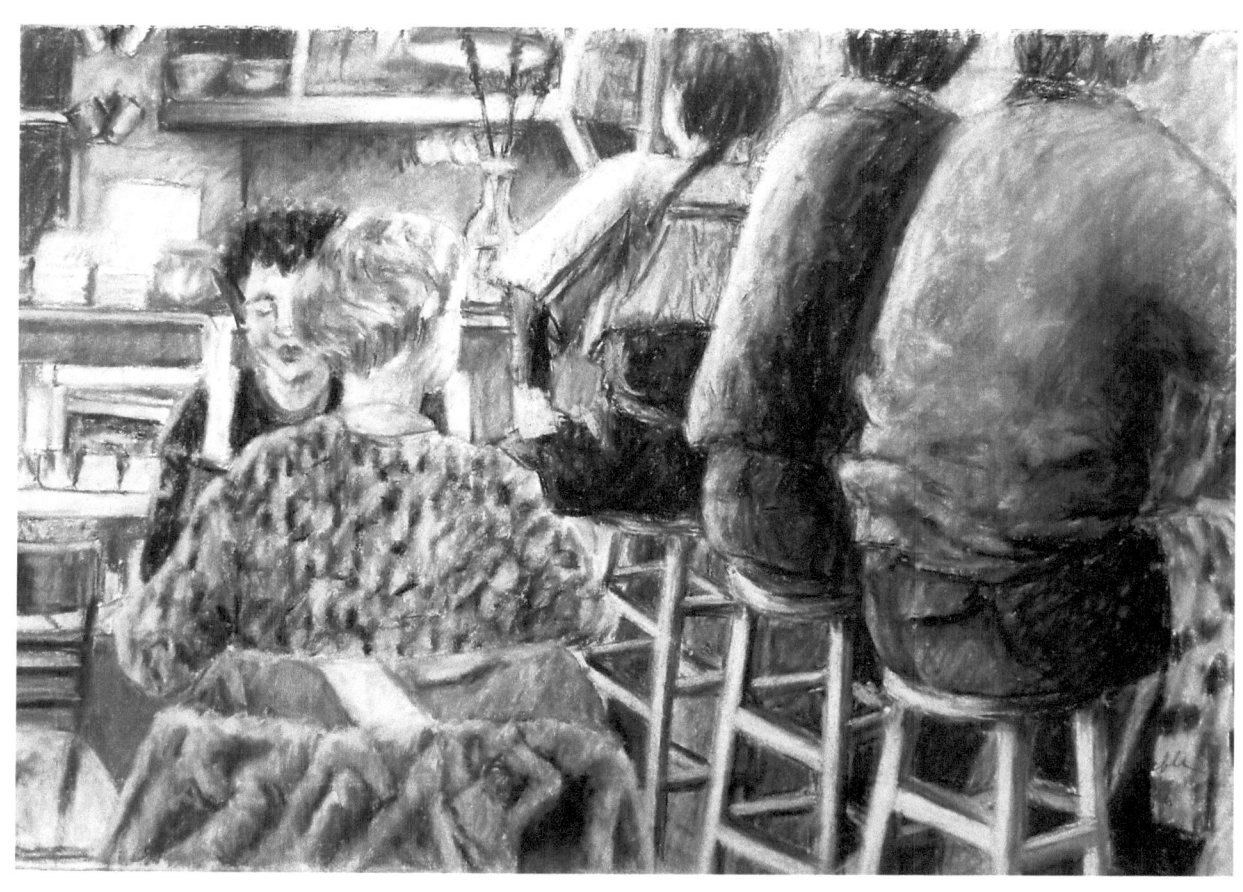

Nothing. So, I'm beyond a certain time, and, entering another. It sounds strange to me here. But, I could get used to it, I am sure. Do I wish to? Do they wish me here? Who are the people of my own age? I saw a punk rocker ask an aging hippie to dance in a club. It was curious to see the difference in the dances of each. One was jagged and jittery and jumping in a frenzy, the other was fluid, soft and gentle in all of her movements. Two generations contrasted by the dances they made.

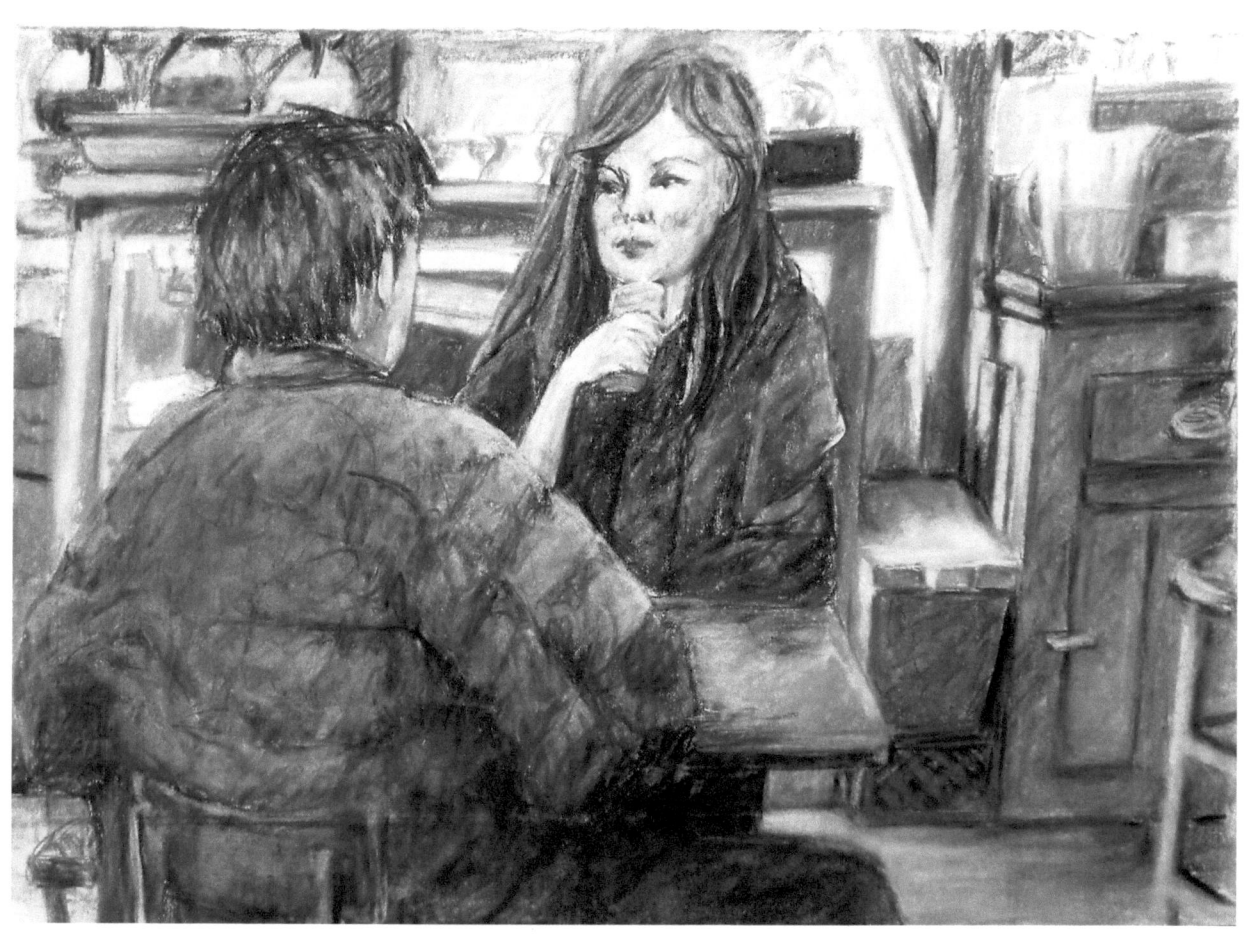

Timothy Leary asked to be cryogenically frozen so that he could be awakened in a hundred years, or whenever they got around to it. I wonder why? Who will be his peers? Who will he talk to about what? Of course, perhaps he felt that way. Who were his peers? Maybe felt that way all of his life. Who have his peers of mind been? Maybe in a thousand years he'll find his partners in mind. Maybe not. I wondered when I heard him talk about it why he didn't just work with reincarnation and try to keep his memory intact.

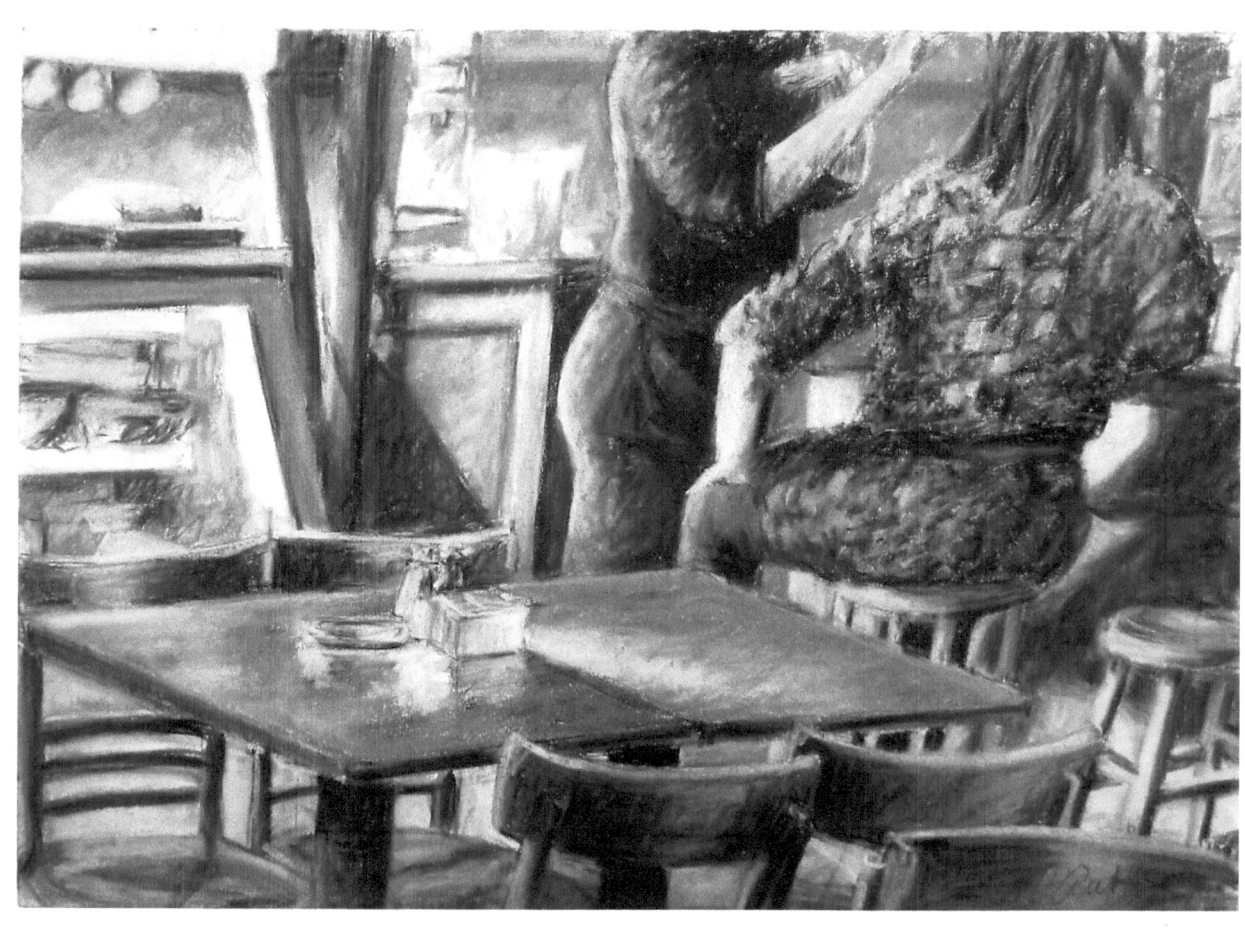

Who would I understand if I live to be 1,000? Other 1,000 year olds would be my peers if they lived that long just like other 9 years olds were when I was 9. Nine year olds don't really play with three year olds. They have a different perspective on the world. Time simply brings with it an understanding of its own age. To be ageless, well, who knows?

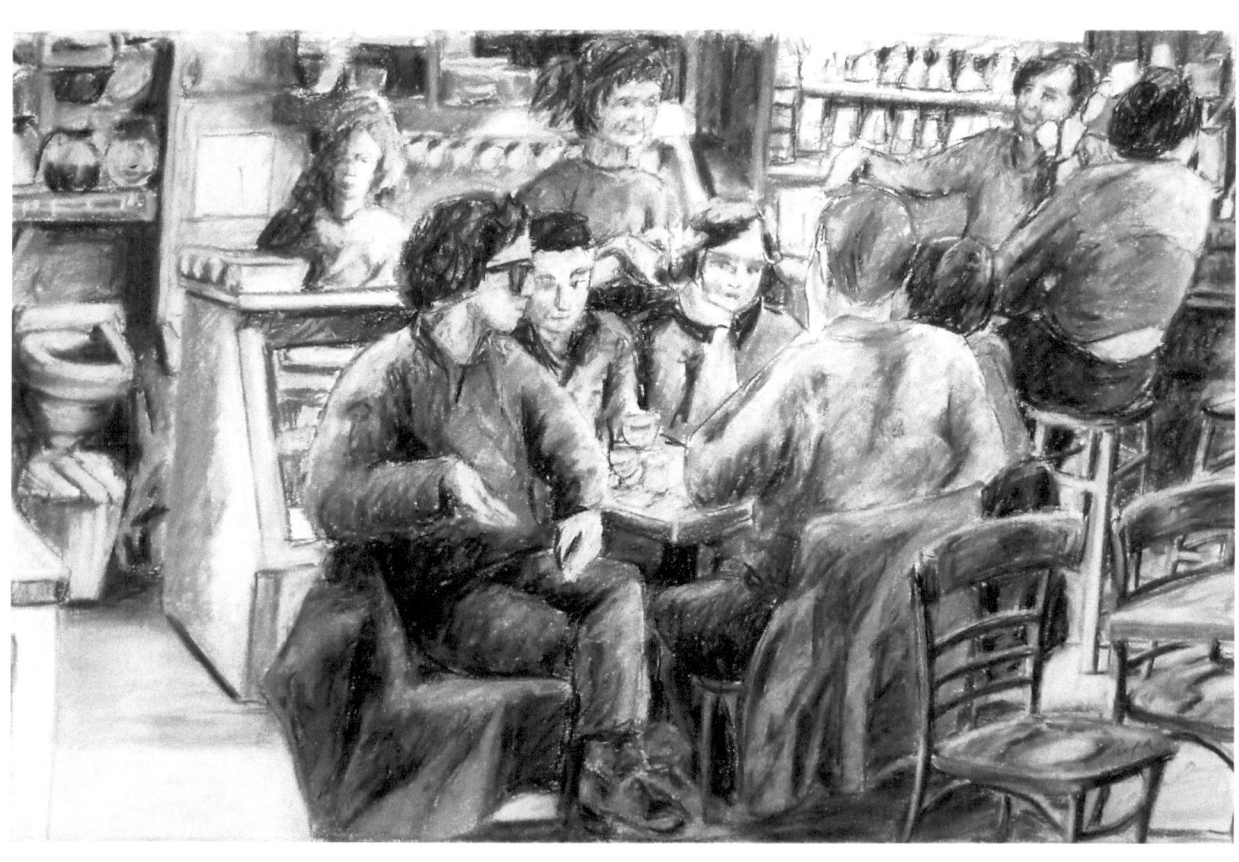

And, if I wait until tomorrow to write this down, what do you think I'll say?

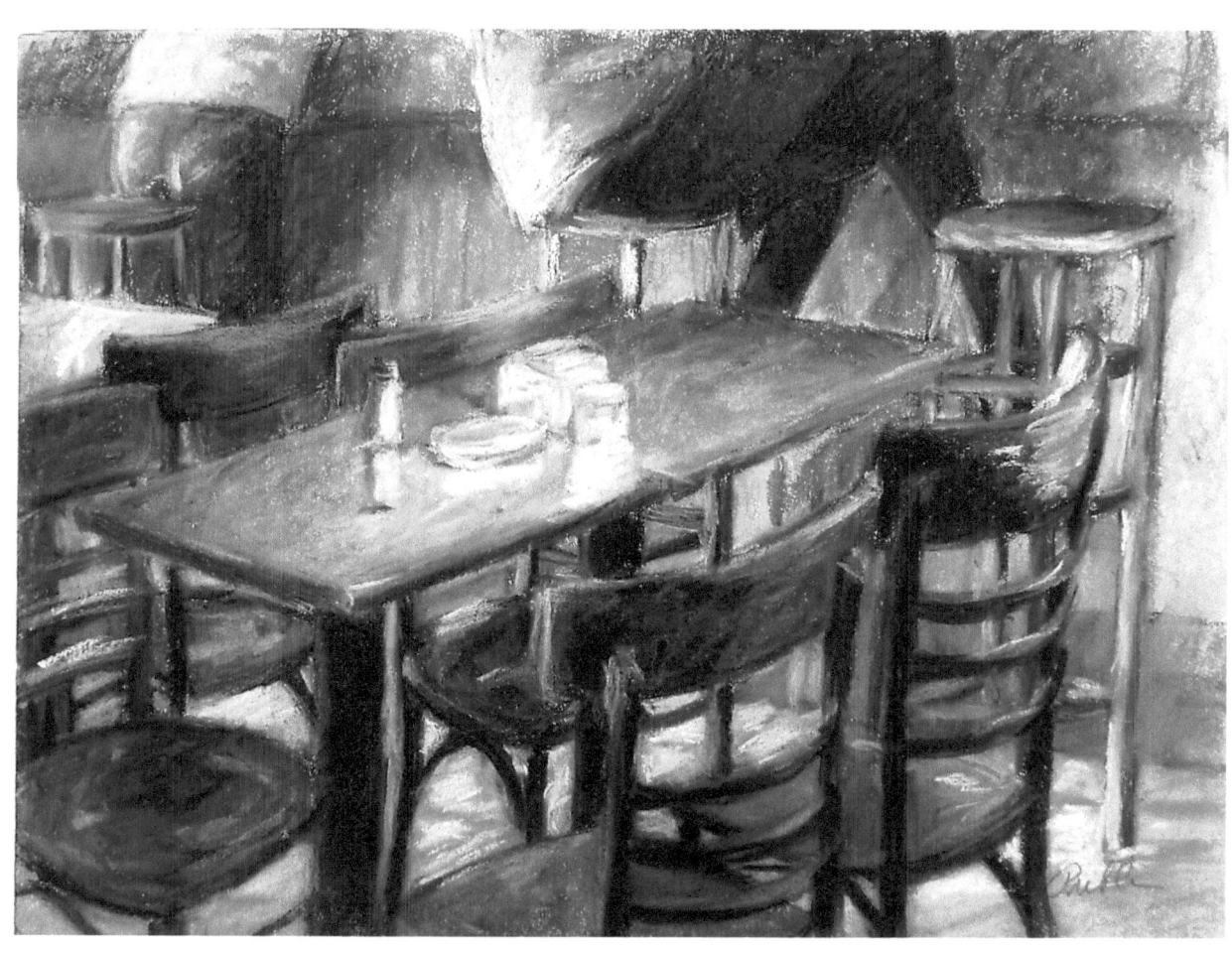

This is the end of the first book.

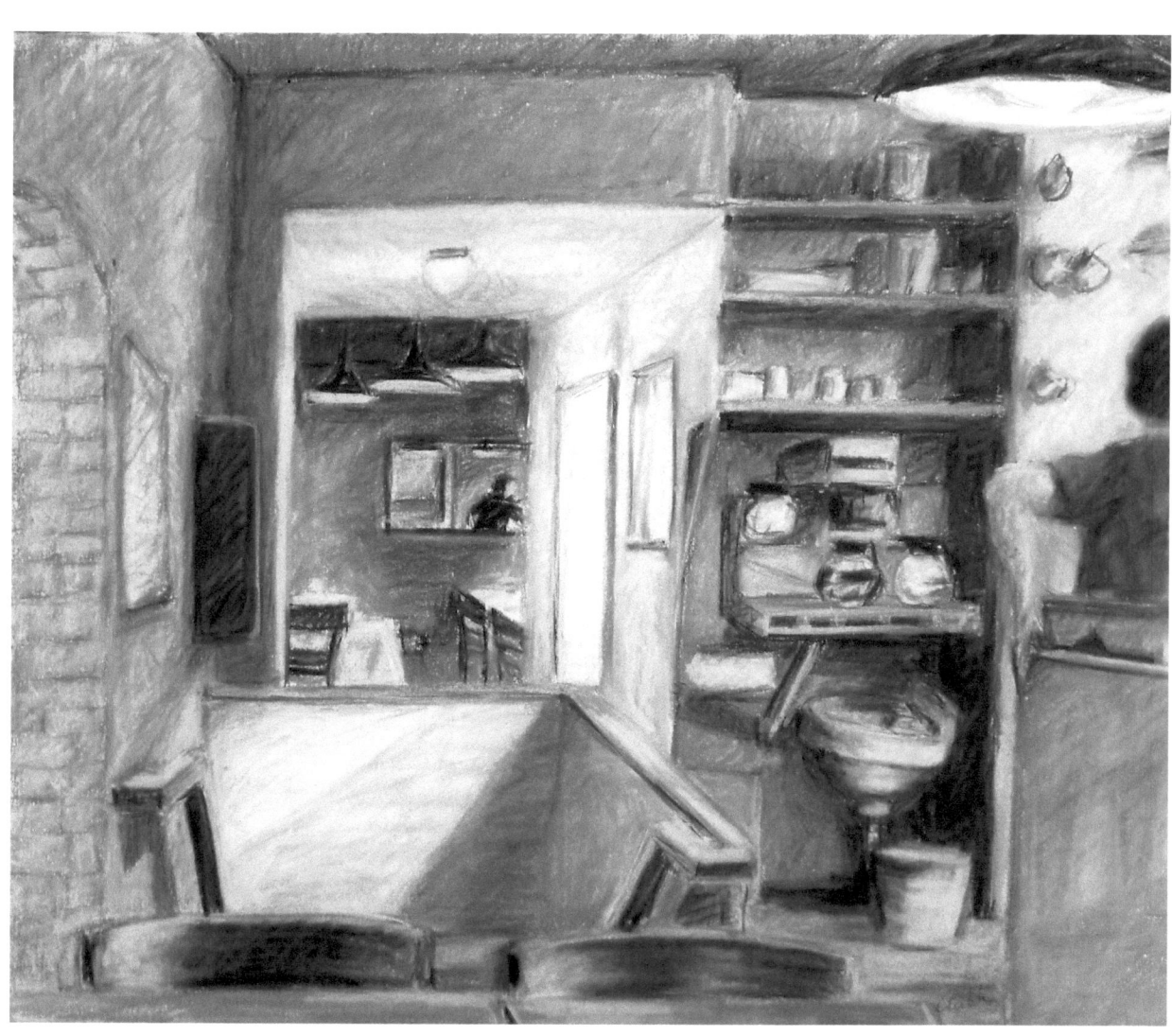

I left a copy of the original Xerox book with the owners of the Café. Some time after the year 2000 they ran across it while cleaning the basement and contacted me. After talking with them I decided to make an updated version of the book. While working on the new version I decided to expand it with a second section to include a commentary about my drawing materials, process and evolution of style.

"I'll Have Another Cup" is my artist's story of how the pictures were created.

I'll Have Another Cup

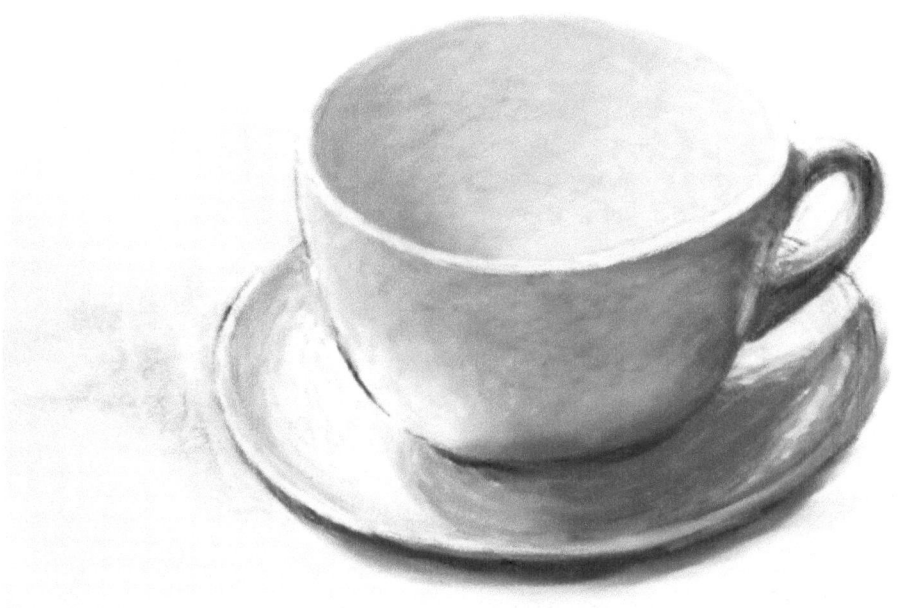

An Artist's Story of How The Drawings Were Made

The Drawing Box

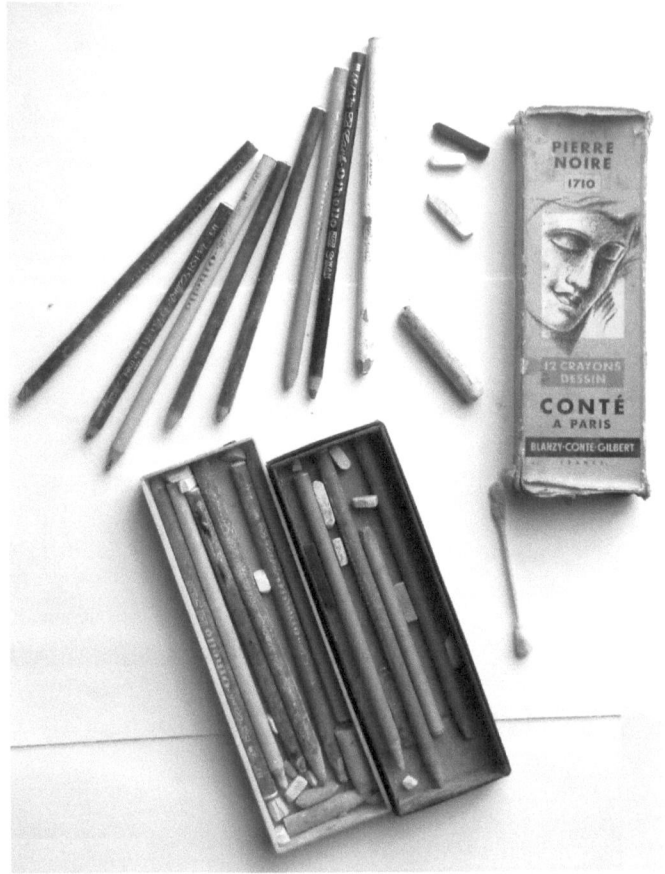

Conté Crayons/ black and white

Conté Charcoal Pencils/ black and white

Rembrandt Soft Pastel – white

Carb Othello Charcoal Pencils by Schwann Company in a variety of tones from light grey to black

The Q-Tip in the above picture was used for blending. I did not use an eraser.

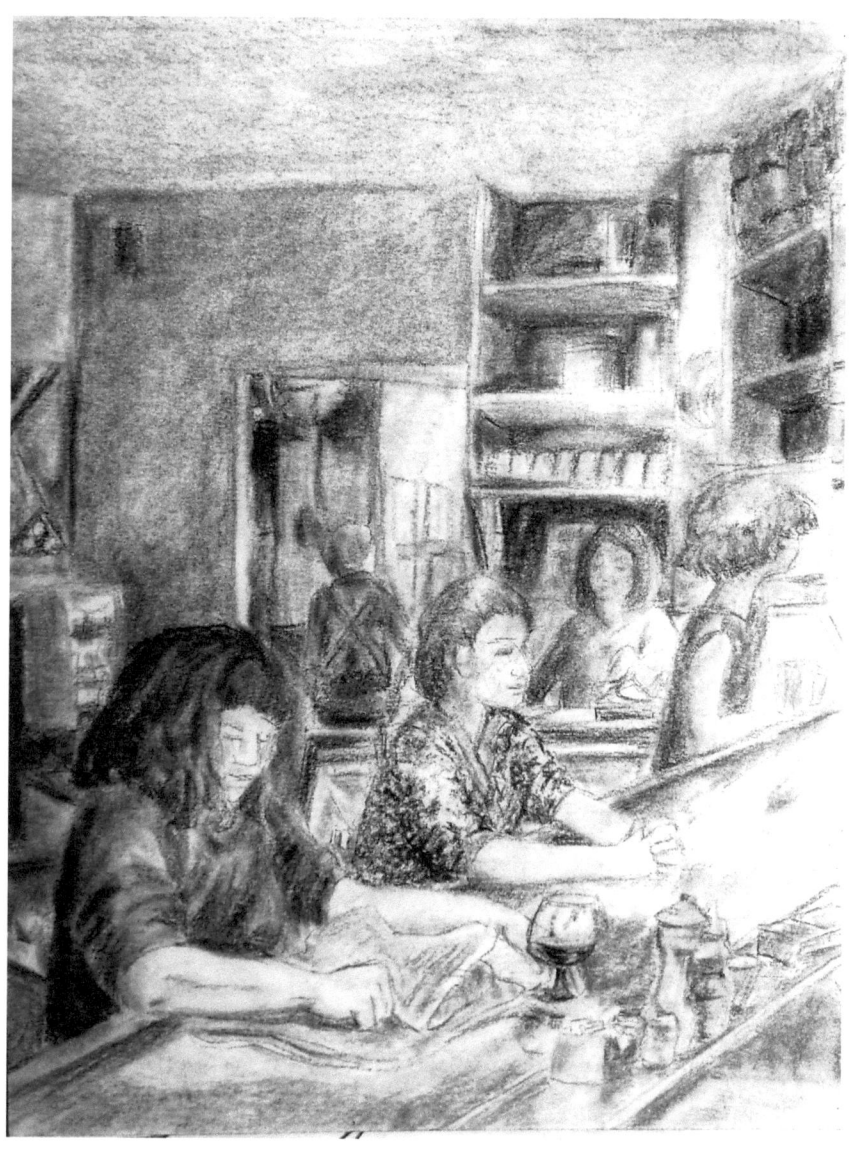

I experimented with different kinds of paper starting with standard drawing paper from a sketch pad. But I wasn't happy with how it looked because charcoal pencil on the rough drawing paper lead to the speckled quality of the surface. I decided to try charcoal paper.

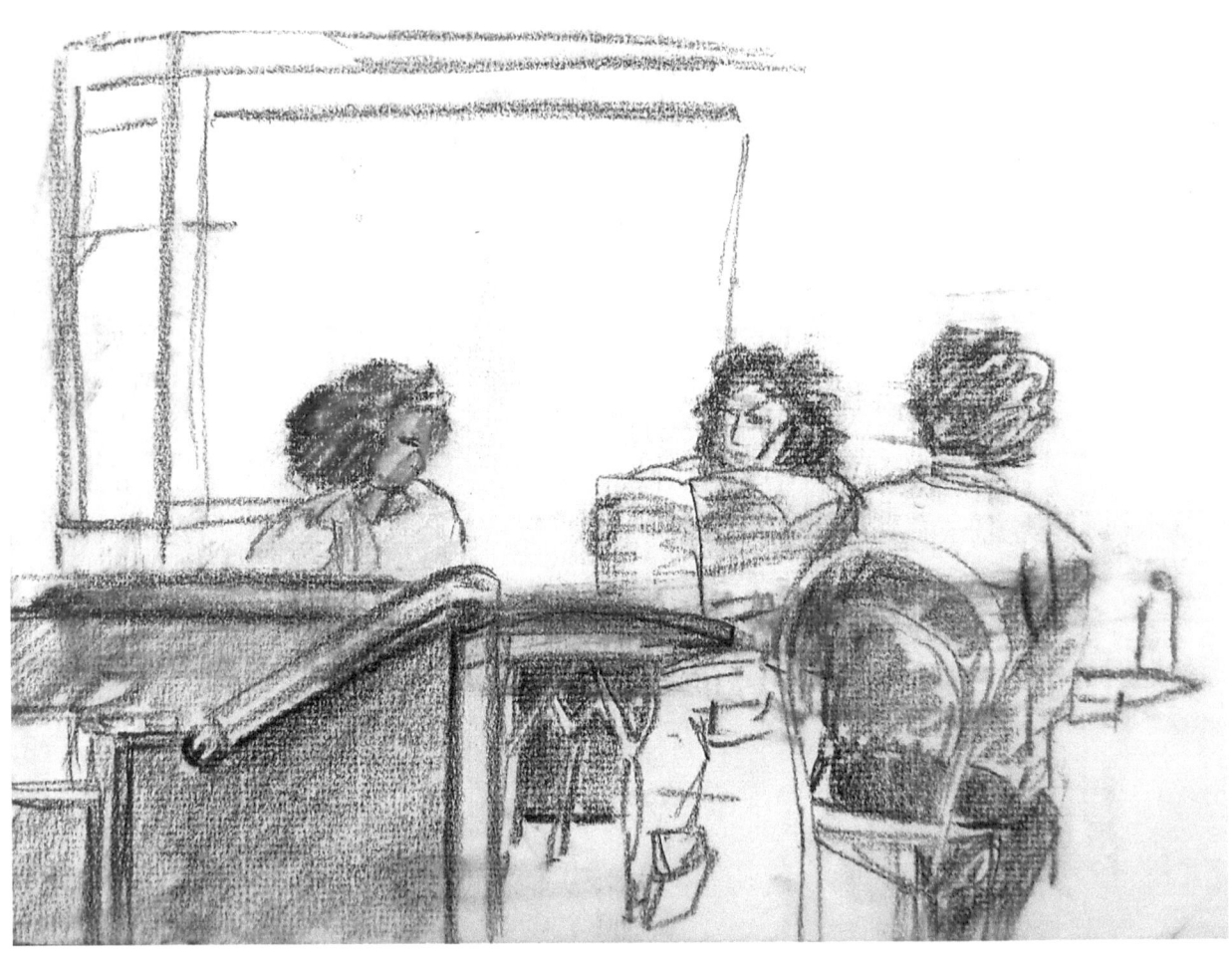

This is an initial sketch on charcoal paper. I was still not happy with the way the paper reacted to the charcoal.

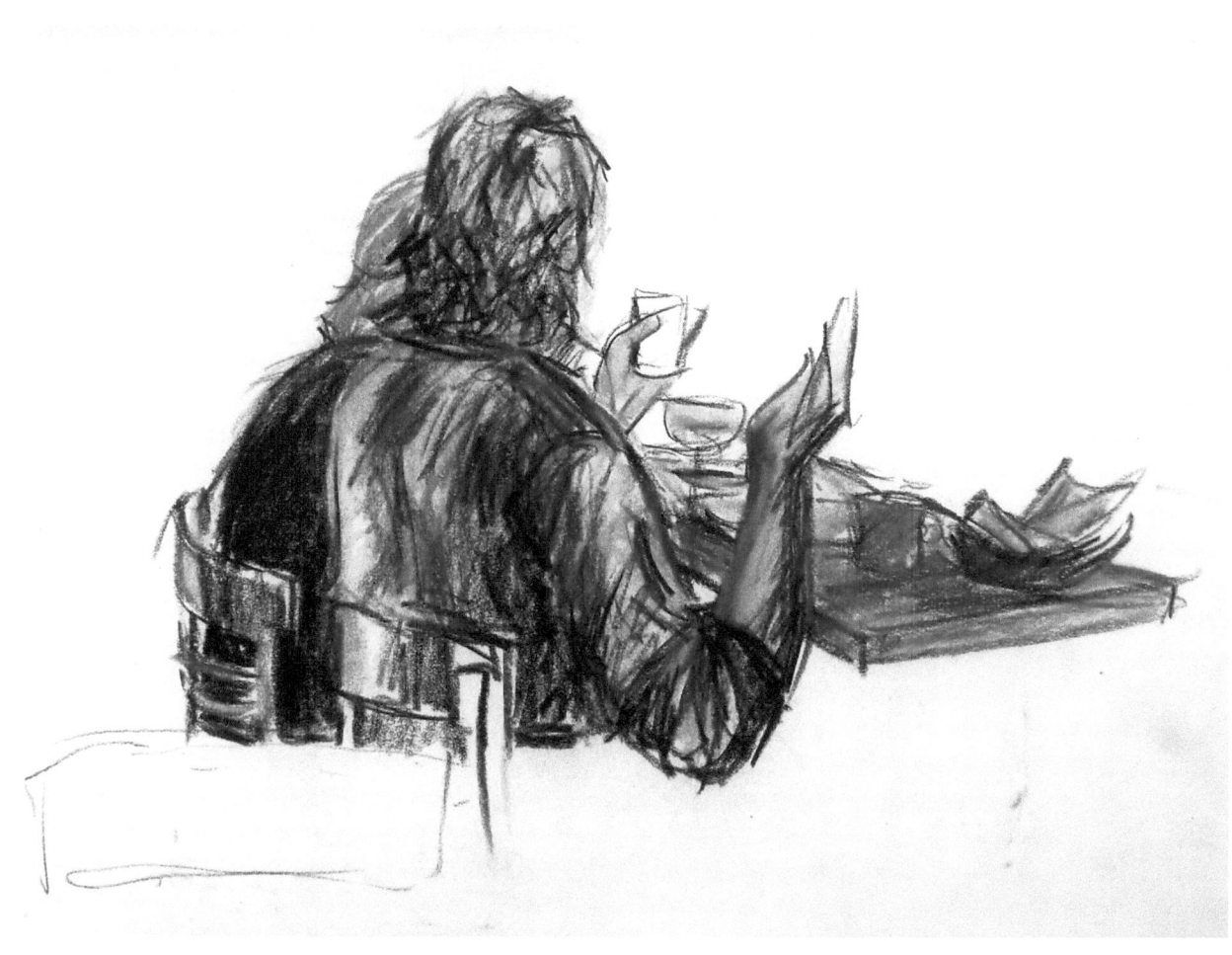

Finally, I settled on papers like BFK Reeves and other print papers. The softer surface of the print paper allowed me to apply charcoal like paint.

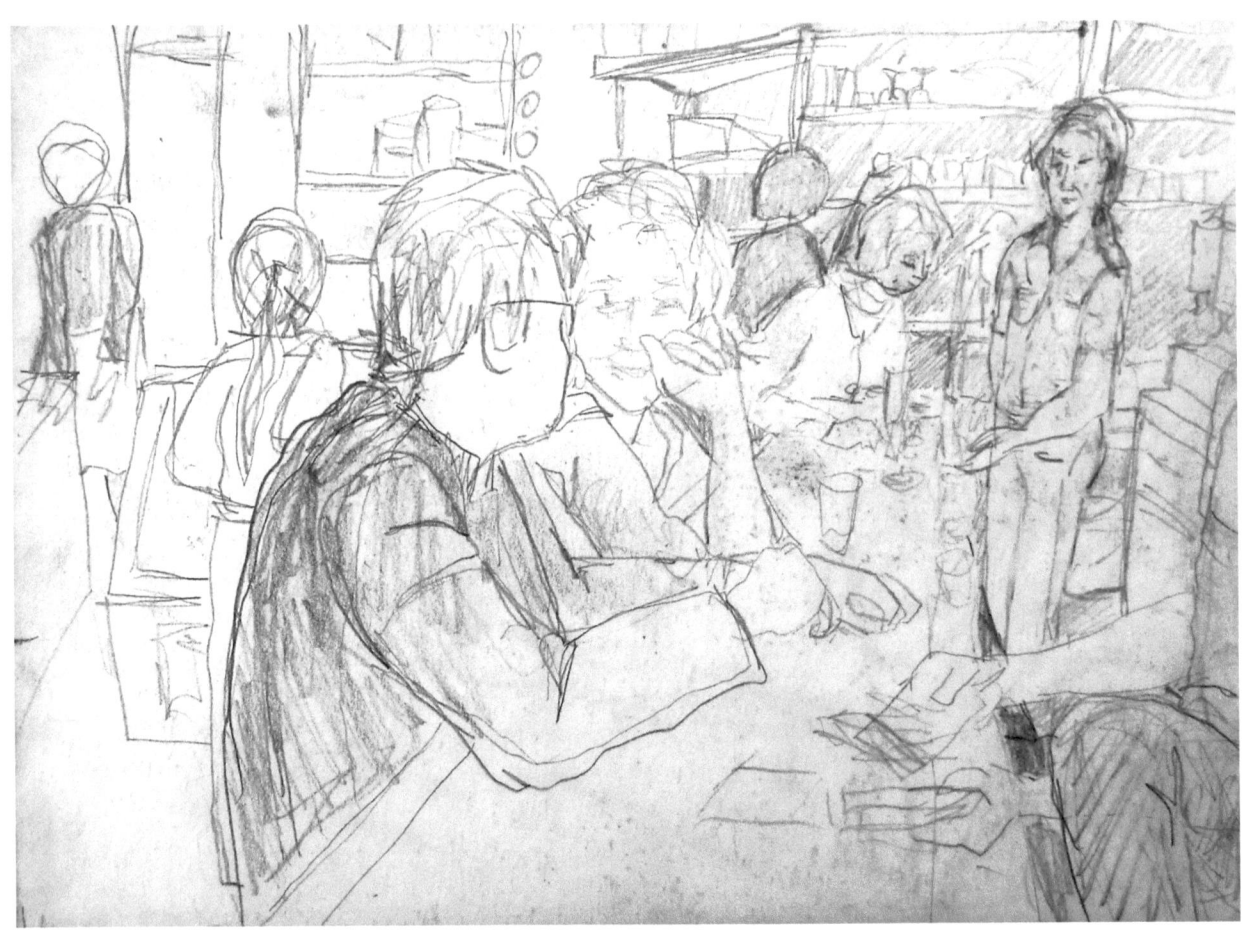

I did not take photographs. I worked on site in the moment.

I would start a drawing with an initial sketch of people in conversation. They would finish their meal or coffee and then leave the café. I had to be quick in order to catch them before they were gone. After the initial sketch was set, I would then go on to fill in the details of the room.

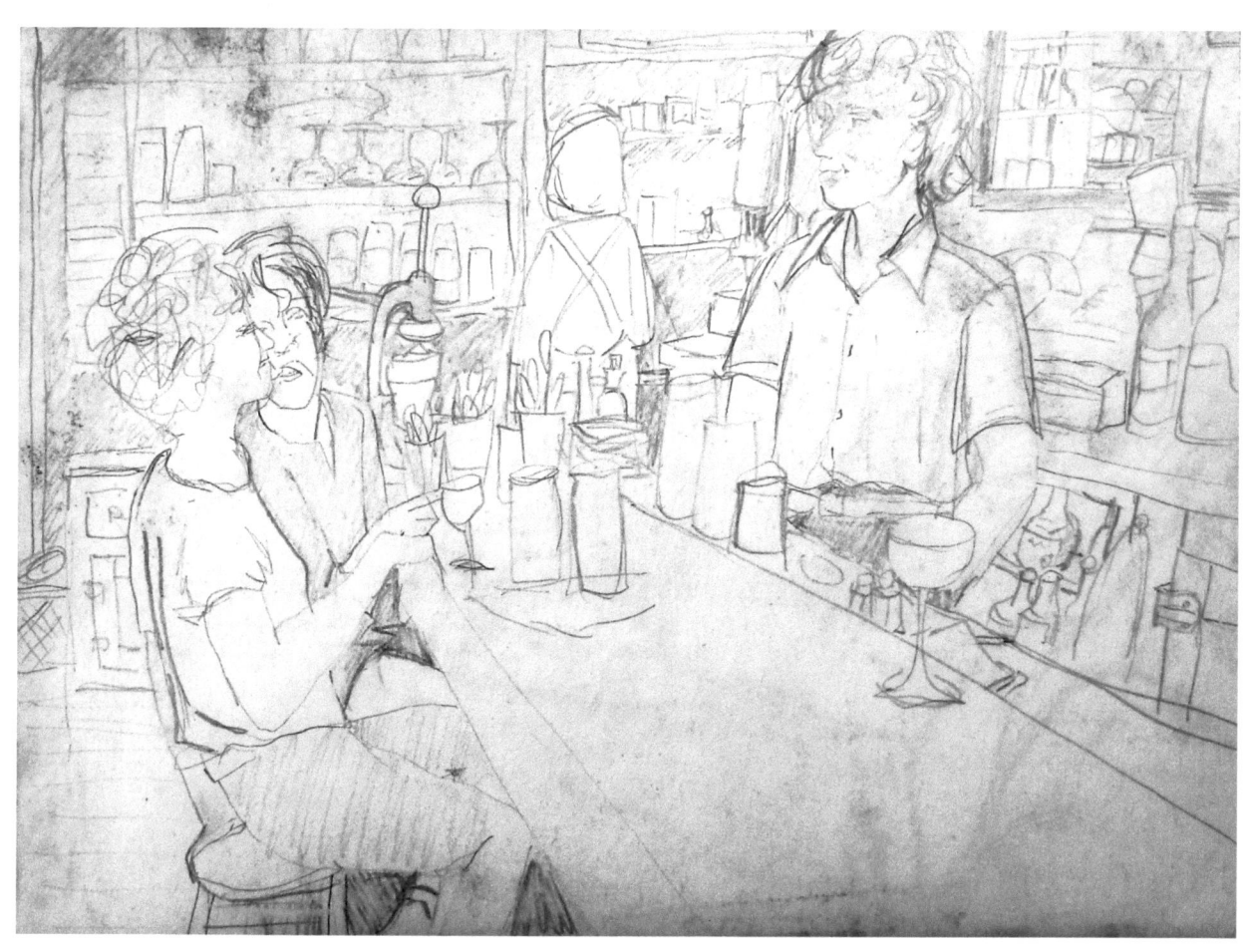

An initial sketch

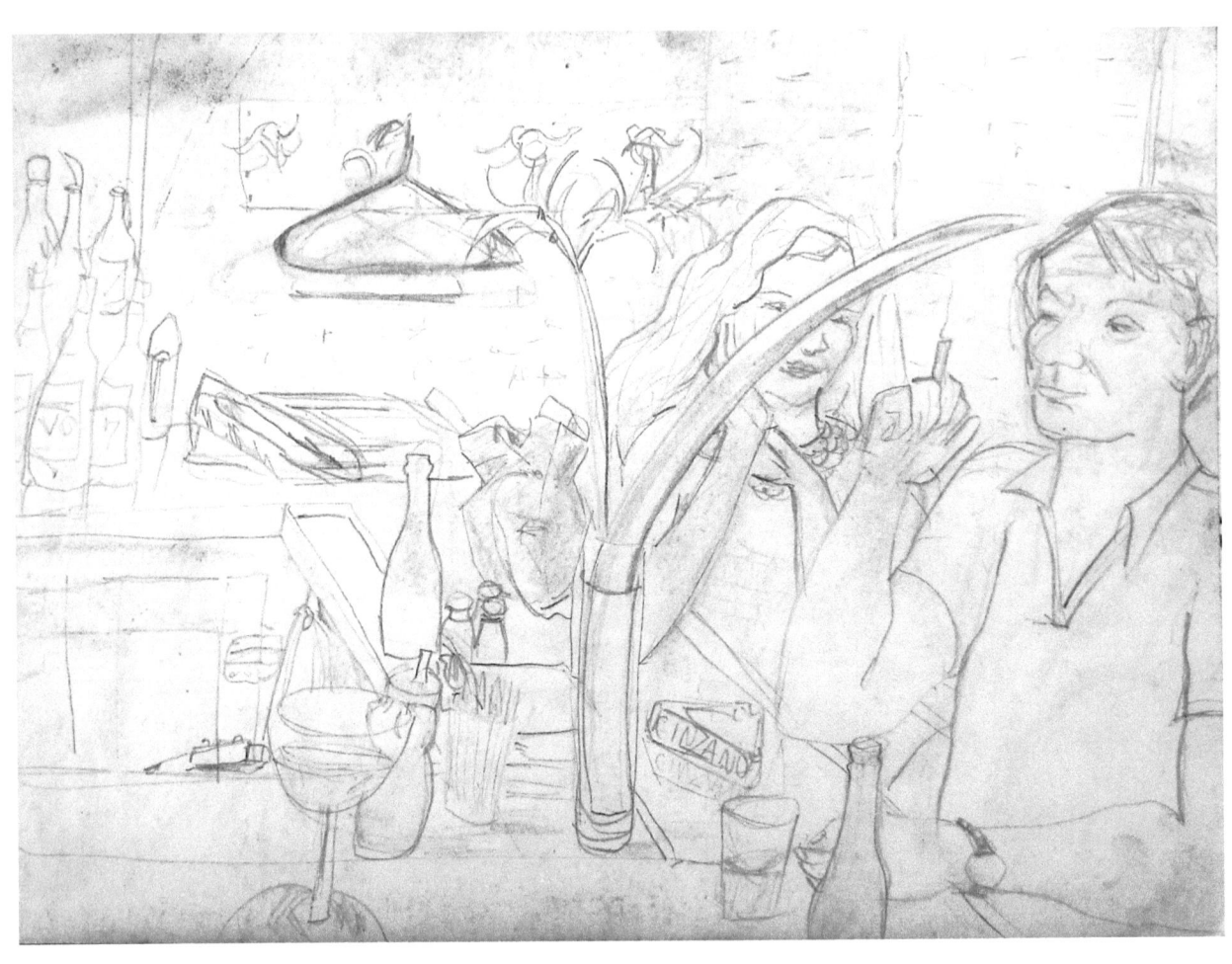

And another initial sketch

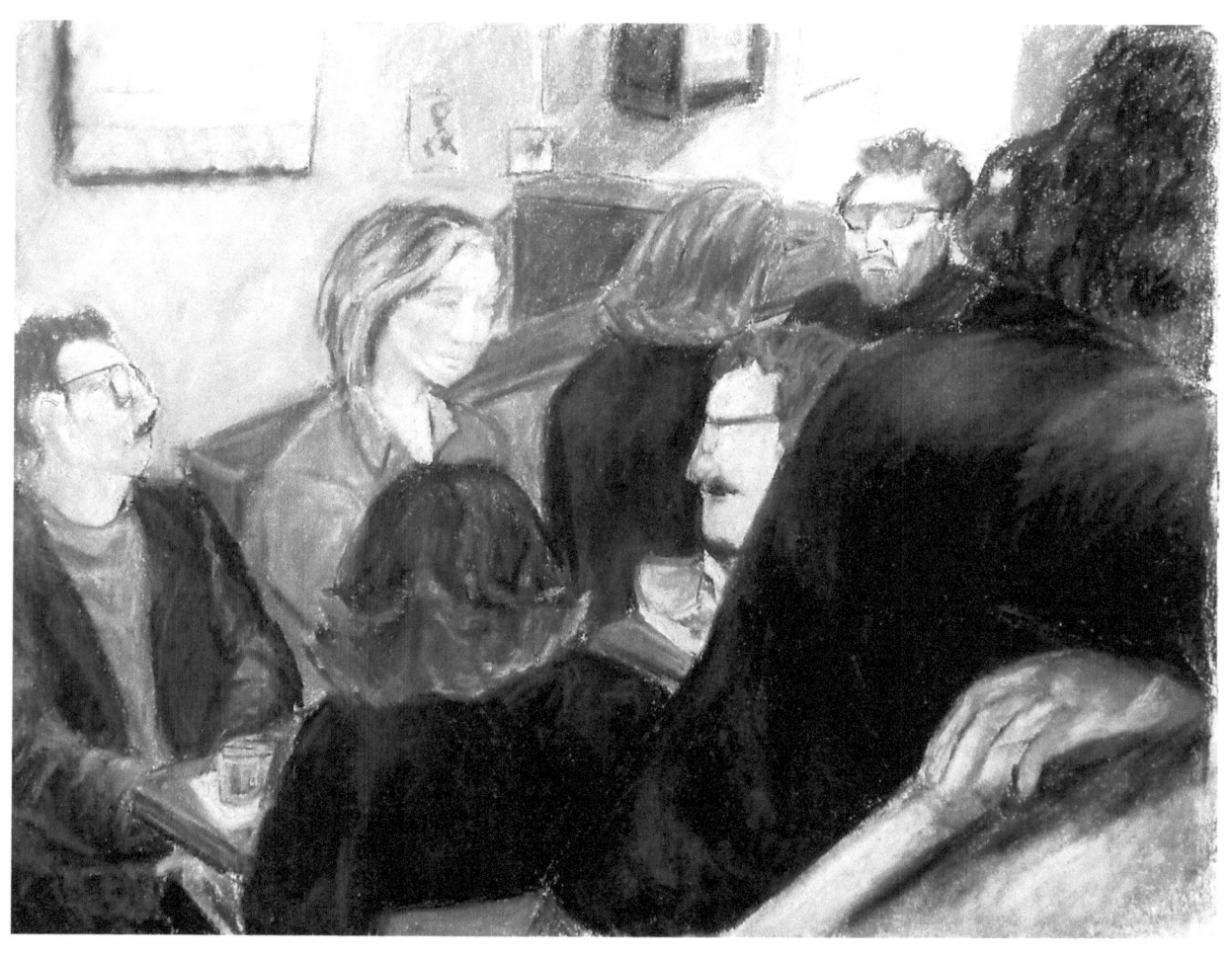

In the beginning my drawings were very tight and constricted.

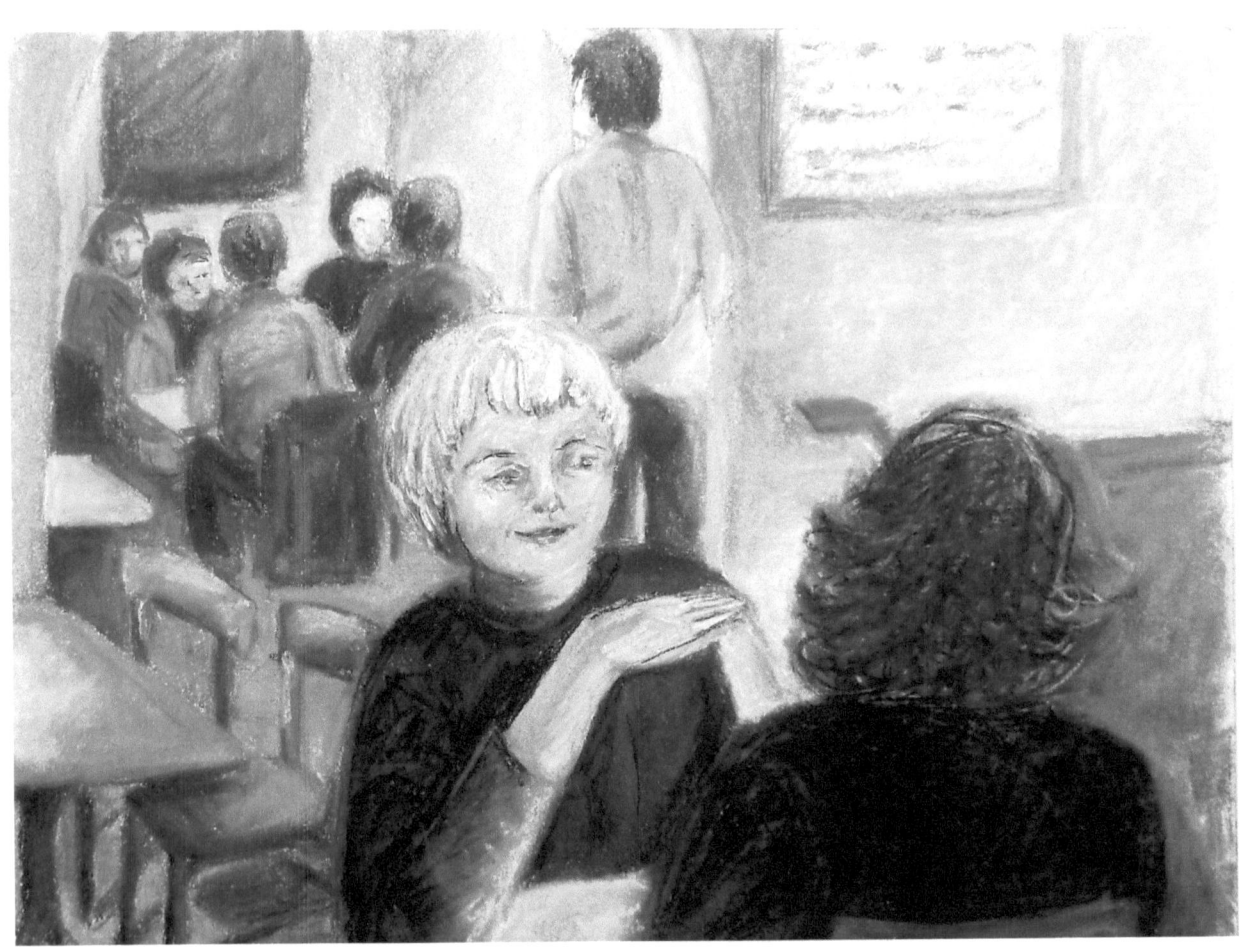

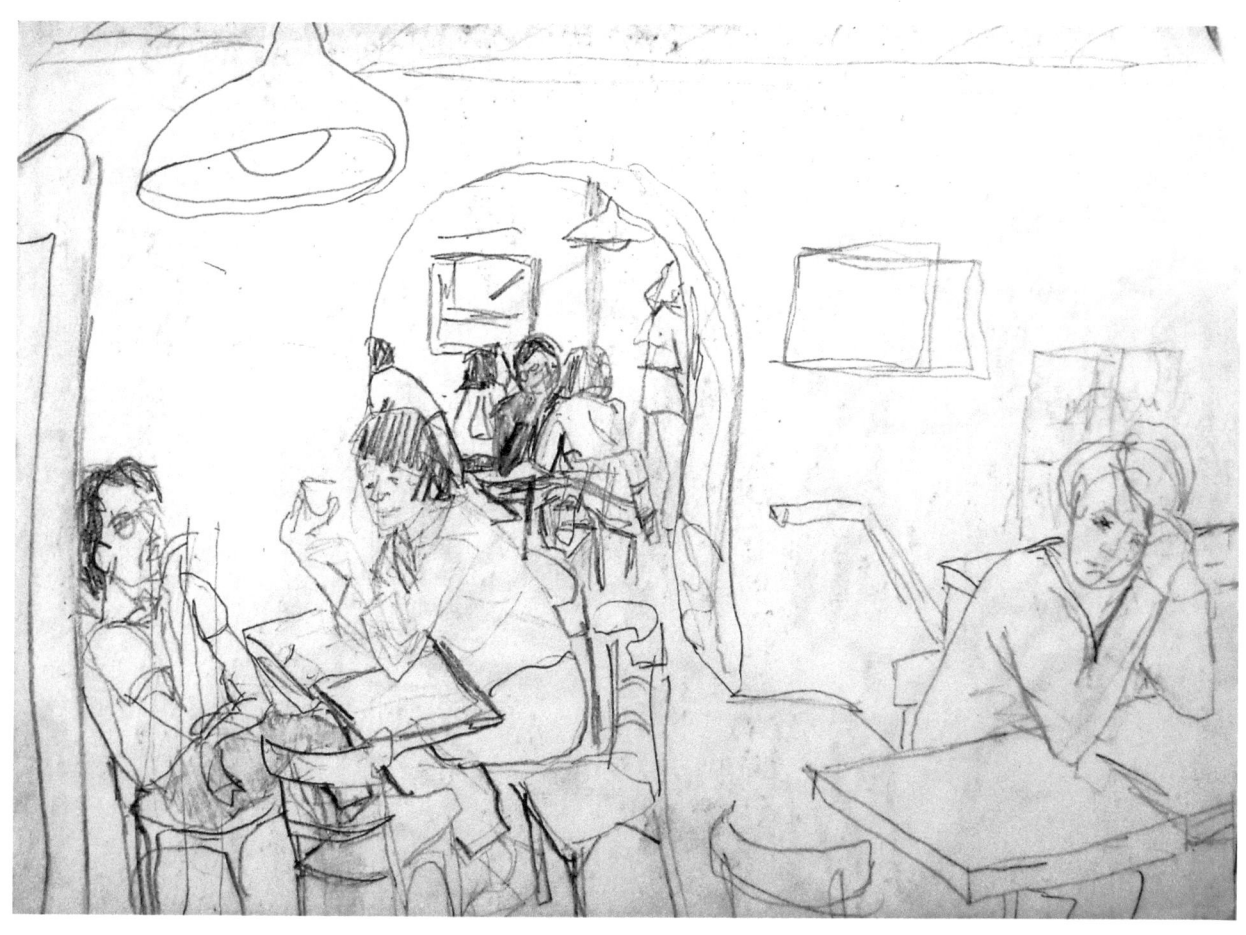

As time went on my drawings began to get looser and looser.

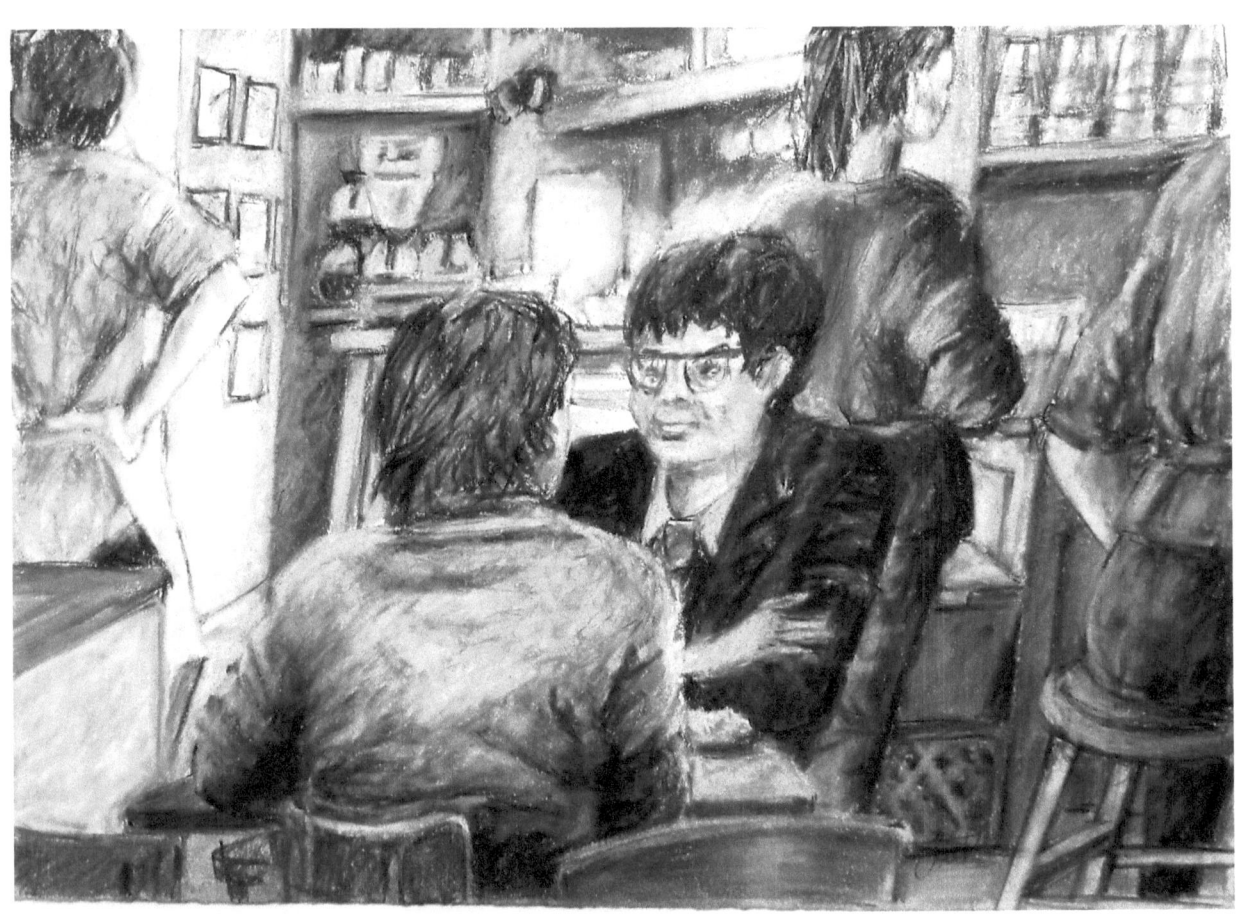

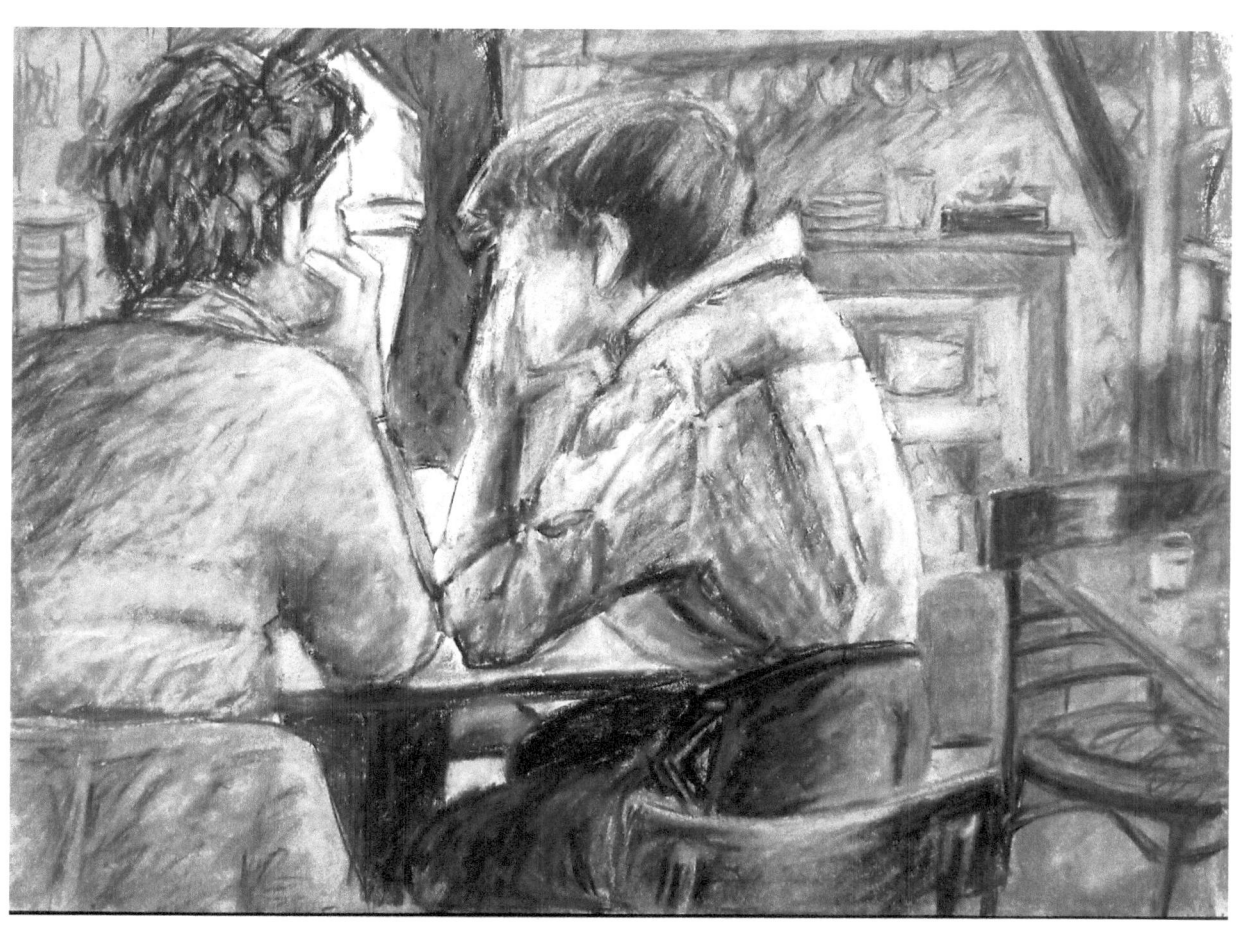

And then more and more expressive

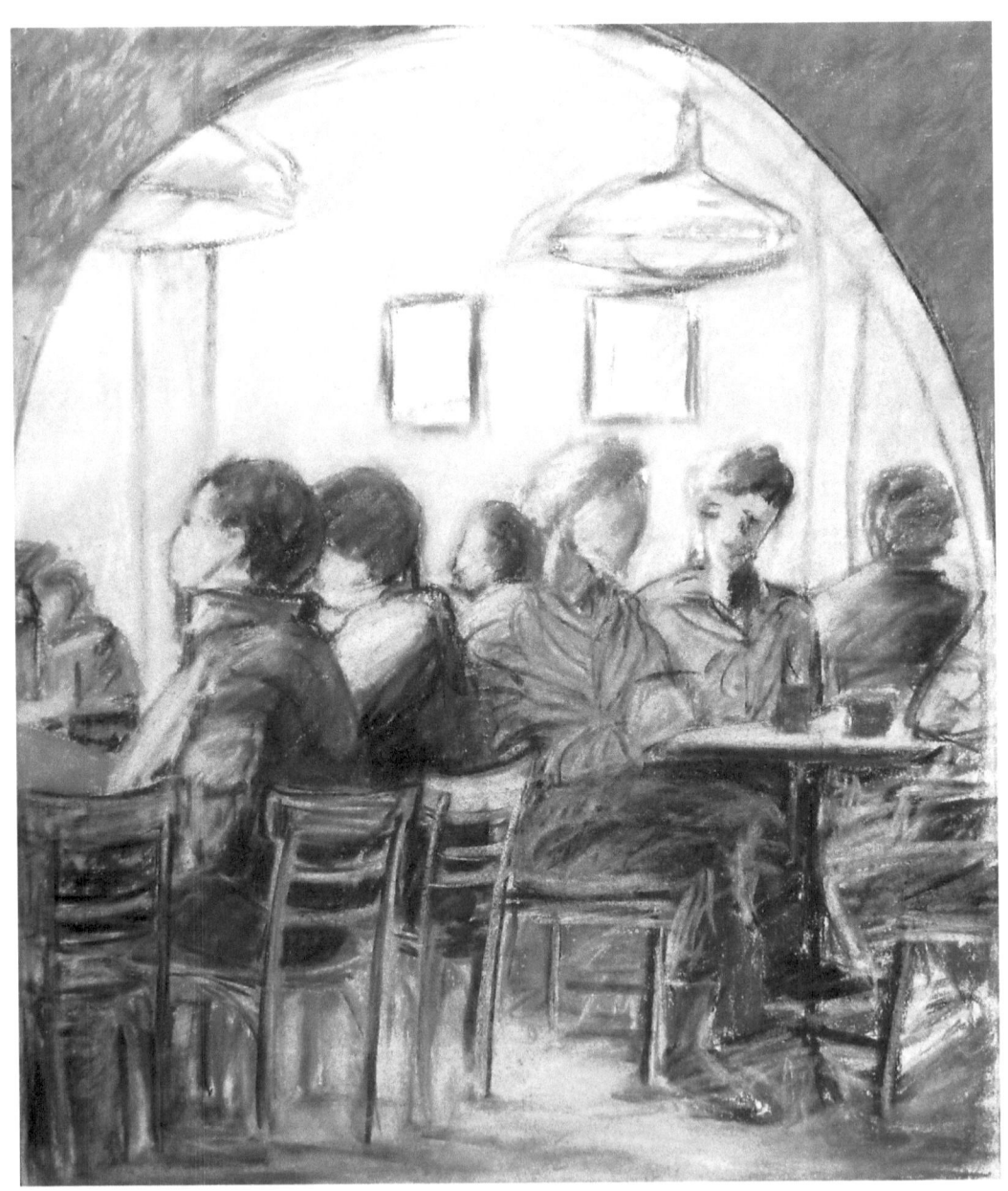

Finally, abstraction began to enter the picture.

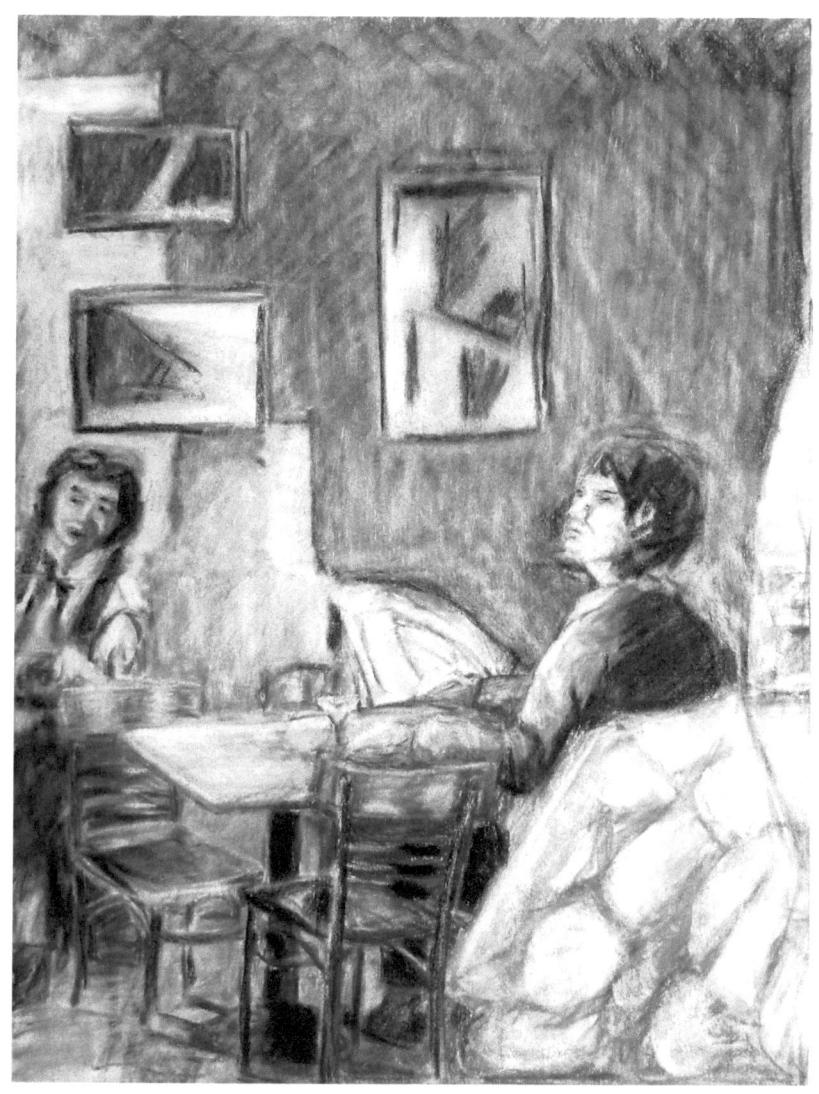

This is the last finished piece of the Cornelia Street Café series. The solidity of the walls has disintegrated and the pictures on display in the café appear to float in mid-air. The fellow at the table is looking toward a distant place and it seems almost as if the coat on the back of his chair is a hand reaching into the picture to pull him

out of the picture as I was pulled shortly after the drawing of this picture to the mountains of Colorado.

Sometimes I wonder about the prophetic possibilities that leak from the subconscious.

I would never claim to be in complete control of what gets rendered. If I try to control the subconscious flow, my pictures get stiff and boring so I do my best to step out of the way and just let it happen. Many times I am surprised by what I see in front of me and sometimes it takes a few years of not looking at the picture before I actually see what is there.

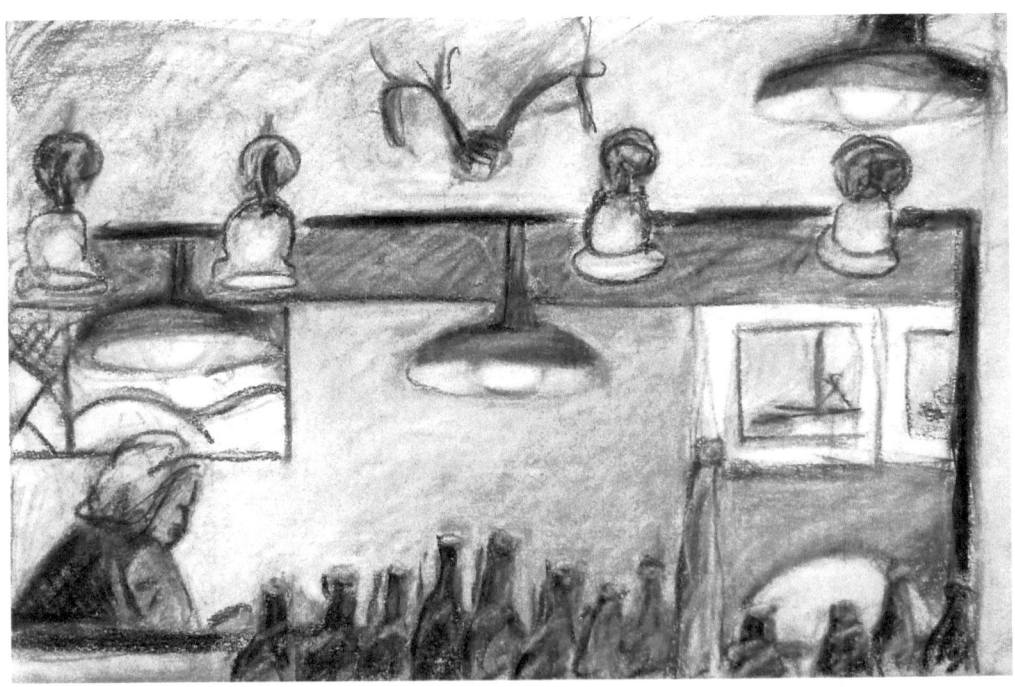

(Mirror behind the bar with lamps deer antlers)

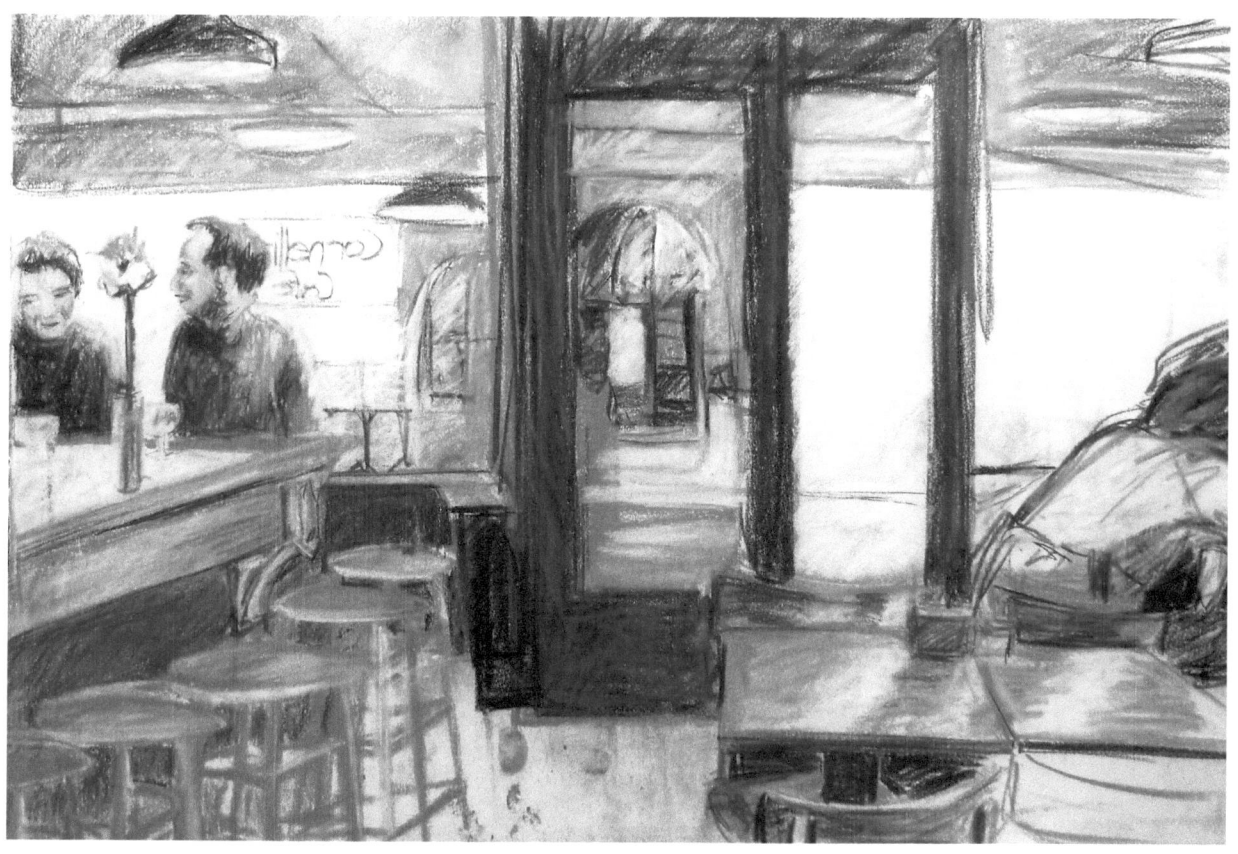

When I left Manhattan I had quite a few unfinished pieces. Some more interesting than others. I like all of the drawings but the partially completed pieces hold a certain fascination for me of possibilities for the direction a drawing can take. Does it have to be filled in completely to be called finished?

The open spaces in this drawing are interesting. I would not change them or add to them now. I enjoy the incompleteness of some areas which stand next to well defined areas in other parts of the picture.

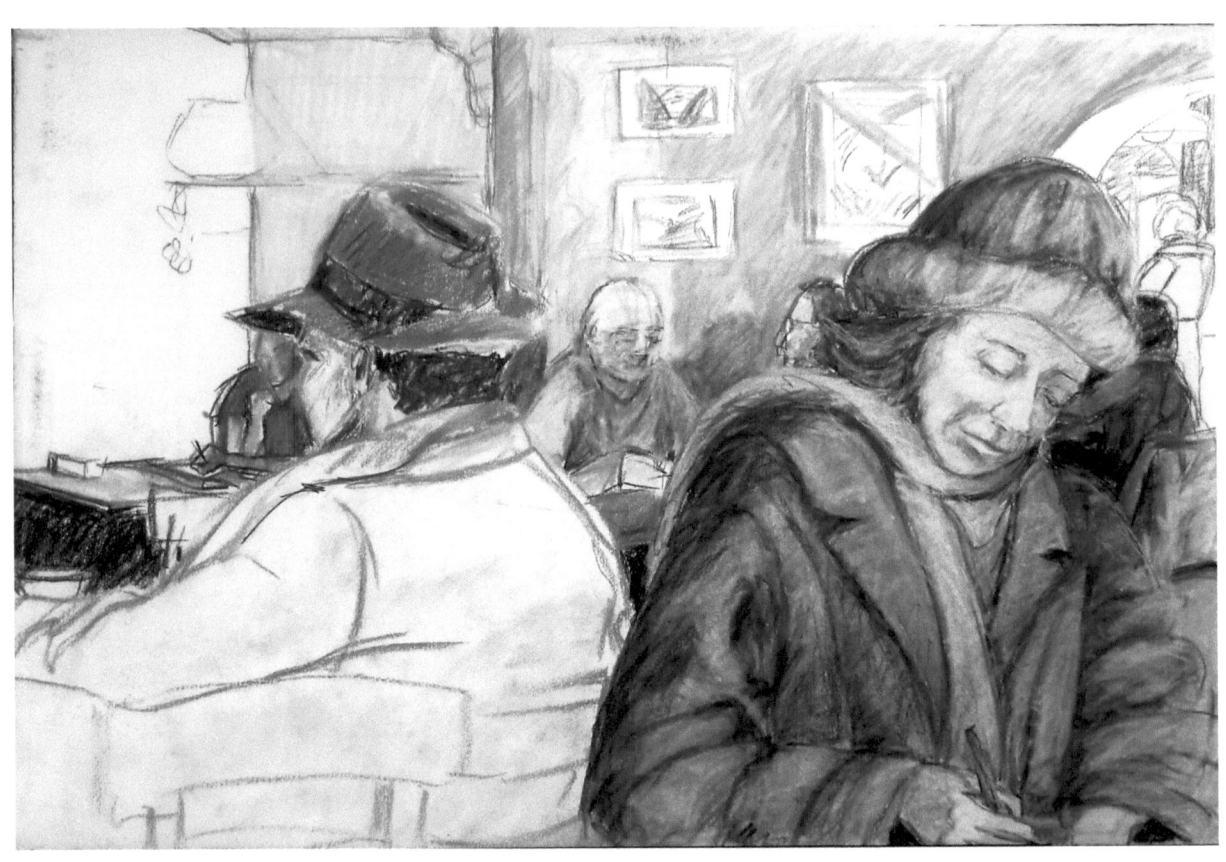

After leaving New York I went back to landscape painting.

My primary painting medium is encaustic but that does not work at all in the field. On site, I was doing pastel and then encaustic in the studio. I became dissatisfied with the level of detail I could achieve with the encaustic process and tried oil, but I did not like the sticky, gummy, smelly stuff. In frustration I did a watercolor painting on a canvas with the idea of finishing it with oil. However, instead of putting oil on top of the watercolor, I wondered if I could use a clear wax encaustic overlay. It worked! Then I spent a few years investigating and resurrecting the Early Roman method of painting which, in part, uses watercolor under painting with a clear wax overlay. You can find information about that whole story in the "Encaustic" section under the "Open Studio" heading on my website.

Moving forward, I have been working up a palette of colors similar to those used in the 16th century Renaissance. This happened because I was struggling to get 'just the right light' in a landscape painting. I was starting to get close to what I wanted and when I looked at the picture I realized that I was subconsciously trying to paint Florentine Renaissance color. After recognizing the color issue, I decided to try using pigments from that time period and see how those would work. There are a bunch of pigments that are no longer used because cheaper, modern equivalents have been made. The problem is that the cheaper modern pigments are harsh and sharp. When I used the old pigments, I was astonished at how soft and lovely the landscape started to look. Now I am working on rounding out my Florentine Renaissance palette.

In other areas, I periodically make short 'art' films for YouTube. If interested, put my name, Pat Preble, in the YouTube search bar and you can find my films.

Some of them are mini documentaries. Some of them are commentaries on drawing. Others are natural sound symphonies.

For more information about my work and to see what else I have been up to please visit my website at www.patpreble.com

Thank you for reading.

www.ingramcontent.com/pod-product-compliance
Lightning Source LLC
Chambersburg PA
CBHW050804180526
45159CB00004B/1544